KINTSUKUROI HEART

More Beautiful For Having Been Broken

Amie Gabriel

Copyright © 2020 Amie Gabriel

All rights reserved

No part of this book may be reproduced, or stored in a retrieval system, or transmitted in any form or by any means, electronic, mechanical, photocopying, recording, or otherwise, without express written permission of the publisher.

Excerpt(s) from RAINBOW IN THE CLOUD: THE WISDOM AND SPIRIT OF MAYA ANGELOU by Maya Angelou, copyright © 2014 by The Estate of Maya Angelou. Used by permission of Random House, an imprint and division of Penguin Random House LLC. All rights reserved.

Cover art & design by: Amie Gabriel

Printed in the United States of America

This book is dedicated to the woman who have - and will have – survived. The owners of a Kintsukuroi Heart... each more beautiful for having been broken.

"We delight in the beauty of the butterfly but rarely admit the changes it has gone through to achieve that beauty."

MAYA ANGELOU

CONTENTS

Title Page	1
Copyright	2
Dedication	3
Epigraph	4
Introduction	7
Preface	9
PART I	11
Chapter One	12
Chapter Two	16
Chapter Three	26
Chapter Four	31
Chapter Five	49
Chapter Six	64
Chapter Seven	92
Chapter Eight	101
Chapter Nine	102
Chapter Ten	124

Chapter Eleven	136
Chapter Twelve	154
Chapter Thirteen	170
Chapter Fourteen	175
PART II	183
Chapter Fifteen	184
Chapter Sixteen	187
Chapter Seventeen	189
Chapter Eighteen	197
Chapter Nineteen	200
Chapter Twenty	207
Chapter Twenty-One	211
Chapter Twenty-Two	217
Chapter Twenty-Three	223
Chapter Twenty-Four	227
Chapter Twenty-Five	228
PART III	232
Chapter Twenty-Six	233
Chapter Twenty-Seven	235
Chapter Twenty-Eight	238
Chapter Twenty-Nine	246
Acknowledgement	249
About The Author	251

INTRODUCTION

Different ages. Different decades. Different circumstances. There are specific events in our lives that shift our paths, write our stories and break our hearts, adding layers, depth and complexity to the clean-slated girls we once were.

Each chapter in Part I of Kintsukuroi Heart is a non-fiction stand-alone story. A collection of vignettes offering glimpses of the exact moment in a woman's life when something happens, either by choice or circumstance, that changes her course.

In Part II we see how these experiences, though deeply personal and unique, are the threads that intertwine and connect us all, fostering compassion and empathy for one another and, hopefully, for ourselves.

In Part III we see how, as women, like all forces of nature and works of art, our beauty is formed through refraction, revealed in dimension and contrast, shadow and light, our benevolence becoming both the result and the salve, the subject and lens. The road may be beastly but the result, if allowed, can be spectacular.

PREFACE

"**Kintsukuroi: kin-tsU-kU-roi** (noun) (v. phr.) 'To repair with gold.' The Japanese art of mending broken pottery with lacquer dusted or mixed with powdered gold, silver, or platinum. As a philosophy, it treats breakage and repair as part of the history of an object rather than something to disguise, understanding that the piece becomes more beautiful for having been broken."

PART I
Moments

CHAPTER ONE
Waiting Room

It was the darkest day of my life. Not the day you might think. Not the day my husband died. It happened before that.

It was early April, the day my husband was scheduled for surgery. That was the day the surgeon emerged from the operating room two hours late – two hours after the time the surgery was expected to end. He ushered us out of the main waiting area and into a private, adjoining room and he closed the door. That's when he told us that he was terribly sorry but they had been wrong. What they were so sure was a blood clot against the portal vein in my husband's liver was, in fact, a large tumor. The cancer was back.

As the saying goes, a little knowledge is a dangerous thing, and in my pursuit of higher learning much time was spent on anatomy, physiology,

and pathology. I'd found the classes fascinating and I'd paid close attention. I'd learned how the human body works, starting at the cellular level. I'd studied the circulatory system; how a cell in the blood stream is transported through the body like a leaf swept along with the current of a river. I understood what a tumor pressed against the permeable wall of a vein could do. I knew that once the mutated cells were loose in the bloodstream there would be no stopping them. I'd studied hard and I'd aced my tests. And so, I knew.

The room started spinning and I couldn't really hear much after that. I remember I had to find a bathroom because I became physically ill. When I returned to the little room, the doctor tried to explain what this all meant. However, my ability to hear and my level of comprehension were intermittent at best. I became intensely aware of the sound of my own heartbeat echoing inside my skull, as though I'd run full speed up ten flights of stairs then cupped my hands over my ears. Sandwiched between the deafening pulses of blood through my brain, I heard bits and pieces of the doctor's attempt at optimism: "Start chemo... got it early... chances are good... still get a transplant..." But I knew.

Only two other thoughts were running through my head. The first, oddly enough, was my deep concern for the people in the next room. In an out-of-body moment of self-observation, I sud-

denly realized that I was no longer sitting in stunned silence, tears running down my face; I was now doubled over and I was screaming. Reality was crashing in and because my body lacked the physical size to contain the enormity of it all, I had unknowingly morphed into a kind of human volcano, earsplitting wails erupting from my mouth. I thought how that must be scaring the hell out of the people in the next room – who were waiting, as I had been, for their loved one to come out of surgery. You see, what was coming out of my mouth was not a sound one would associate with humans. It was the sound of mournful horror. A primal manifestation of terror and disbelief. It is the sound that would come out if the Earth cracked open and all of hell spilled forth. Because, in that moment, I knew.

The other thought was this. We had been so hopeful, so sure, that this surgery was the opening of the door to recovery. This surgery was the last hurdle to be cleared so my husband could get on the list for his liver transplant, and a long, happy, healthy life was ahead. We were so close and we were so excited.

But it wasn't the case. This, instead, was our worst nightmare. Still, I knew one more thing had to be done that was even worse than what was happening now. With this realization, I bellowed as I felt myself falling into the abyss.

Somewhere within these hospital walls, the sweetest, kindest soul lay deeply sleeping, blissfully unaware. In a few hours, he would be awake. How, in God's name, would I tell this to my husband?

So, on the seventh of April, on a beguiling spring day, the lights went out, the walls closed in, the sky fell down and the rug got pulled out from under me, all at once. It was the beginning of the end of the world. And I knew.

CHAPTER TWO
Tipsy

They were just going to get tipsy. That was the goal. Two childhood best friends, born two years apart but attached at the hip, as their mothers would say.

They were eight and ten years old when they met on the school bus in a quiet New England town. The younger girl moved in down the road from the older girl and they became fast and constant friends. Around the rest of the world they were shy, gawky and insecure, but when they were alone together, they became relaxed and silly and bold. The comfort they felt in each other's presence allowed them to be their true, best young selves.

They lived less than a mile away from one another on either side of a state park that the locals called The Castle, and the several hundred

acres of woods that lay between them was their playground. They fancied themselves woodland creatures and this was their kingdom. It was their enchanted forest, full of folklore, fairies, and frogs. They were princesses and tomboys in equal measure. You were just as likely to find them knee deep in the Castle pond, catching fish and bullfrogs with their bare hands and running through the woods like wild animals (moms' words again), as you were to find them singing Scarborough Fair in a round and pretending their horses were unicorns. Like twins with a secret language, they knew each other's thoughts, and like sisters, they could fight like cats and dogs.

Each turn of the season brought new adventure. They belly-crawled through spring meadow grass, seeing just how close they could get to wild cottontails, and peered over the pond's edge where gelatinous masses of frogs' eggs hatched into pollywogs. They caught fireflies in jars on warm June nights and found refuge from the hot afternoon sun under the generous shade of the pines. They washed away the sticky New England air in the inground pool behind the younger girl's house and in the dammed-up creek in the woods behind the older girl's home. They spent cool, rainy weekends listening to music and working puzzles in the older girl's playroom, her mother making them lunches of chicken noodle soup and buttered bread. They rode their bikes through

the swirling autumn leaves, the older girl always riding faster down the hills. They gathered up the cast-off plumage of oak, maple and birch into enormous piles and dove in, delightfully smashing crunchy handfuls into each other's hair. Though the houses on their road were few and far between, they knew all their neighbors and all their neighbors knew them. They went trick or treating on Halloween night and caroling on Christmas Eve, flashlights and the moon through the bare arms of the trees lighting their way. They built snow forts, and sledded down their driveways or any clear hill they could find. Their childhood smelled like rich, sweet earth and decaying leaves, like horses and saddles, like skunk cabbage, bullfrogs and wet rocks. It smelled like honeysuckle and hot tar, like melting snow and raindrops, like wood smoke and pine. Their childhood smelled like the deep New England woods.

When they had grown to adolescence, the woods offered cover as they gleefully spied on the boys at the private academy down their road. Like secret agents, they moved from tree, to rock, to tree, silently inching closer to the edge of the grassy school grounds, straining to get a better look at their crush du jour. On the rare occasions that they were discovered, they always had a well-planned escape route – like the time a big twig snapped loudly underfoot and gave them away. It was an all male boarding school and when the

boys clapped eyes on the two girls in the trees it was like ringing the dinner bell for hungry field hands. One of them yelled "GIRLS!" and they all came running. "Oh, nice move, Hiawatha!" one girl teased the other and they screamed and laughed with giddy horror as they stealthily disappeared into the trees. The boys gave chase but the academy's dorms housed young scholars from all over the state – meaning: this wasn't *their* woods. Once the girls had vanished into the forest, which they had come to know like the back of their hands, the boys had no prayer of finding them. Plus, the boys weren't allowed off campus.

And so, it was. There would be first dances, first kisses and puppy love, and like the safety and sanctuary of their beloved woods, their friendship remained. Until one day the news came that the younger of the two would be moving away. *Far* away. A long plane ride away! It was a leveling blow and there was melodrama and many tears, but the decision had been made. In consolation their families promised that they could visit.

The following summer, the promise of a visit was kept. It was on this trip that the idea of their first foray into the forbidden world of adult beverages came up. They were thirteen and fifteen years old, and they relished one other's company as much as ever. They had a sleepover at the older girl's house, just like old times. They sang every word of their favorite songs, giggled over crushes,

debated the pros and cons of having short hair verses long hair, and stayed up to see if anyone good was on the late-night talk shows.

"Have you ever had a drink?" the older girl asked.

"Huh?" the younger girl said.

"A drink. You know, *booze*!" whispered the elder.

"No! Have you?" the younger replied.

"No." And after a long pause, "Do you want to try it? We can raid my parents' liquor cabinet!" Half intrigued but always afraid of getting in trouble, the younger girl said, "I don't know. I kind of want to but... what if we get caught?"

"Oh, pfft! We're not gonna get caught. It's not like we're going to get falling down drunk. We'll just get a little tipsy! C'mon, live a little!"

"OK," the younger girl agreed, "we'll just get a little tipsy!" She giggled when she said the word. It was such a silly word and, by virtue, it felt pretty harmless.

They could not, however, just waltz over to the liquor cabinet and pour themselves a drink, so before they left the older girl's bedroom, they had to have a plan. Having never "drank" before they weren't quite sure how to go about it. What should they drink and how much? They didn't know, so they decided they would just take a little bit from every bottle. It was the best way to leave no obvious evidence of their theft, since no one

bottle would look like it was missing anything when compared to the others. They also decided that, once poured, they should bring it back to their room to drink, to lessen the risk of getting caught in the act.

It was late. The older girl's parents were asleep in their room down the hall and she needed to keep it that way. She gently clasped the doorknob and turned it as far as it would go. Willing it into silence, she eased open her bedroom door. She could hear light snoring coming from her parents' room. They slipped out into the hallway, their bare feet on the carpet making no sound. Barely breathing, they moved in slow motion as they crept onto the stairs, toes hovering for an instant just above each step before making contact. Freezing in place when they thought they heard something. Regaining movement when the sound of light snoring confirmed the coast was clear. Step... *wait*... step... *wait*... step... *wait*... They moved like ghosts.

Finally, they made it into the kitchen. The door to the liquor cabinet was one they'd never opened before. They knew where it was and what was in it, and there was an unspoken rule that it was strictly off limits but, until now, they hadn't cared; they'd been far more interested in where the chips and cookies were kept. Tonight, that changed. Tonight, they had a laser focus on the bottom corner cupboard. Behind its

door they imagined a portal into another world, a GROWNUP world. They opened the door to the cupboard and stared at its contents for a minute. In the windowless hallway, their eyes had fully adjusted to the darkness and, although they'd turned on no lights, the kitchen – with double windows over the sink - seemed bright by comparison. They stared at the bottles; some tall, some round, some square, some with textured glass and some with smooth. The low light of the moon through the windows glinted on the glass and danced on the surface of the various potions. It had already begun to intoxicate them.

They grabbed two tall milk glasses and, silently working their way through the bottles, poured until each glass was about two-thirds full. Then, armed with their contraband, they tiptoed back to the stairs.

Once returned to the safety of the bedroom, they got right down to business. They stood facing one another in the middle of the room, glasses in hand, eyes locked. There was no turning back. They were excited to cross a threshold and leave part of their childhood behind.

"You ready?" the older girl asked.

"Yeah," the younger girl whispered, quickly nodding her head.

They clinked glasses, whispered "cheers" and, bringing glass to lips, never losing eye contact, they each took their first tiny, timid sips.

"BWAH!" the older girl said in a huge expulsion of air as her eyes flew open wide. A shudder ripped through the younger girl's body from head to toe, like a wet dog flinging off water, and she said, "Holy shit, it burns!"

They quickly gathered themselves and regrouped, looked at each other and nodded, indicating they were ready to go again. They took a second tentative sip. This time it went down just a bit easier. As the older girl pulled the glass away from her lips, she watched in horror and amazement as the younger girl kept going. She tipped the glass back, gulping down the rotgut concoction like a third-year frat boy. She chugged it all to the last drop without coming up for air, and with the bottom of the empty glass facing the ceiling and the rim still to her lips, she fell back on the bed behind her. Arms splaying out wide, milk glass loosely in hand and staring at the ceiling, she just lay there, astonished, waiting to see if she was going to puke

"Holy, shit!" said the older girl, laughing. "Are you ok? How did you do that?"

"I don't know," the breathless, younger girl said, and as a smile moved across her lips she added, "but it felt pretty fuckin' good."

She started to laugh, softly at first then louder and louder and, as a feeling of complete and utter release came over her, she raised her voice and

said, "Holy SHIT!"

"Shut *UP!*" said the older girl in a frantic hushed voice. And through her teeth she hissed, "You're gonna wake up my parents!"

Still lying back on the bed, the younger girl laughed and yelled out at the top of her lungs, "I DON'T GIVE A SHIT! I DON'T GIVE A SHIT ABOUT ANYTHING!" The feelings of self-doubt had left her. The low-grade anxiety that had been her constant companion for as far back as she could remember was gone. The worry of displeasing her father had vanished. The fear of not being good enough and that nobody liked her had disappeared. She felt free. For the first time in her young life, the invisible, inexplicable burden she'd carried on her narrow shoulders and the soft pressure, like a hand on her chest, had been lifted. Fears, pressures and weights that she didn't even know were there until now, were gone. Having no other frame of reference, she had no sense or awareness of something that had always been there... until it wasn't.

That night she never did wake up her best friend's parents – and the trip to the liquor cabinet was just another one of their thousands of secrets – but she'd gotten way more than tipsy. The girl who was shy and sweet and far too sensitive for this world had tasted freedom. And a demon had entered her young body leaving behind a key and a map.

The next day the fear and the pressure were back but now she was aware of their presence... and a way to make them go away.

CHAPTER THREE
White Porcelain

The water rushes onto her head, washing her down, surrounding her with white noise and taking the last of the lather with it, down and away. Fast down her shoulders and back, it cleanses her; when she shampoos her hair, when she soaps her skin. Even the dark places where the soap can't reach. That place far back in her mind and deep in the pit of her gut where her past lives. The place where, if she's not very careful, her memories can make her dirty again.

The spigot makes a slight high-pitched squeal as she turns off the water. She reaches for the towel that she placed, neatly folded, atop the shiny white toilet tank, right outside the combination shower and tub.

When she was first shown this small apartment three weeks ago, she was pleased to find the bath-

room had all white porcelain fixtures and original tile. She liked it. No real reason at first, it just looked nice and crisp. She quickly discovered that if you're careful and keep it clean and wipe the water spots up before they dry, it always looks so shiny and new, though it probably dates back to sometime in the early '60s. Its outward appearance defied the years of abuse, the tears, broken glass, blood and scum it had, no doubt, endured. And after all that, all it took was a good scrubbing and a buffing with a clean, dry towel and it looked sparkling and as good as new again. It doesn't escape her that a bathroom with white porcelain can keep a lot of secrets.

She takes the pale blue towel and lets it unfold. As she buries her face in it, she inhales its freshness. It was clean. It didn't smell of mildew or of someone else. It was new and clean and it was all hers. She patted herself dry and wrapped the towel tight around herself. She gently pushed aside the white eyelet shower curtain her mother had given her and stepped over the side of the tub onto the matching pale blue bath mat. The towels and bathmat, and nearly everything else in the apartment, were gifts from her mother for housewarming. Her mother would have given her anything to keep her safe and warm. It's how she was... and she was just so grateful to have her girl back in one piece.

She removed the towel from her tall, gangly

frame, bent over at the waist and wrapped it around her head like a turban. Sparingly she applied her lotion, walked into her bedroom and slipped on the clothes she had laid out for herself, making sure to keep a light on only in the room she was occupying.

Tonight, she would wear jeans, her new lavender V-neck sweater (that sort of looked like cashmere) and a pair of black boots with medium high heels. She wanted to look nice but not like she was trying too hard. She turned out the bedroom light, went back into the bathroom and quickly blow dried her hair and brushed her teeth. As she put on her makeup, being careful not to make eye contact with herself, she began to wonder how she'd... "Stop it," she said out loud, scolding herself. Her chin dipped toward her chest and her hands dropped to the corners of the sink as a way of steadying herself. She froze, barely breathing. Thinking about anything other than the simple tasks at hand wasn't doing her any favors (especially after what happened a couple of days ago). She breathed, closed her eyes and, having gathered herself, softly said "OK." She finished by putting on a little apricot lipstick and a bit of gloss, ignoring the slight trembling in her hands. She took her matching hand towel and dried out the sink and left it nice and shiny. It was so easy to buff the surface and make it look pretty. You certainly couldn't tell that someone had just spit in it. She

neatly draped the towel over the rack so it would dry, and snapped off the light. She grabbed the black dress coat that she had worn to her new job and headed out the door. She hadn't felt up to arranging a ride for tonight, so if she wanted to catch the 7:23 pm bus she'd better move.

After less than a minute's walk down her street, she arrived and sized up the other people at the bus stop. A woman, about twenty-five years old, held the hand of a little girl who looked about four. They were both bundled up against the cold city night and the little girl's dark eyes shone with a smile in the lamplight. Upon her arrival at the bus stop the two women instinctively exchanged glances and a quick smile – *safety in numbers.* A boy of about sixteen, who seemed deeply committed to communicating his taste in all things retro-punk via his posture and wardrobe, sat slouched over, hands jammed into pockets, feet propped on the seat of the bus stop bench and his butt on the backrest. Lots of piercings, spiky black hair, unlaced combat boots and a leather motorcycle jacket that was way too thin to keep him warm in this weather. I guess it's not too cool to let on that you're freezing your skinny ass off. Anyway, he's harmless.

The city bus rolls up and the doors slap open. She lets the mother and child go first then she makes her way up the steps, dropping exact change into the fare box, and finds a seat where

she calculates someone is least likely to sit near her. She'd be there in ten minutes, although she doesn't want to go. The thought of it terrifies her. If she goes, she'll have to talk to people and she'll have to tell them the truth so maybe they can help her. She wanted to call out to the driver to wait. She wanted, with every fiber of her being, to bolt off the bus and run like hell, but the only thing that frightened her more than going forward was going back to where she'd been. She knows that, like the memories that haunt her, some ghosts are real. Some ghosts are real and they can hurt you. So, she doesn't call out and she doesn't run. She forces herself to stay quiet and to stay put and, although she's scared to death, she goes anyway. She goes because, despite her cool, polished exterior, she is desperate. The driver shuts the doors and off they drive into the night.

CHAPTER FOUR
Baptism by Fire

It was time. She had allowed her past with him, and the fact that he had left her, to define her for long enough. She had assumed the healing would evolve over time, a lovely benefit born of self-awareness and personal growth, but it clearly hadn't happened – she wasn't moving on with her life like she'd promised she would. At this point, she felt she was going to have to do something to help her crawl out from under the shadow of her past and to officially start over. But how? How to let go of something... of someone... who had been such a huge part, not only of her life, but of how she saw herself?

She had loved being his wife. He was the guy everybody loved and she had such a sense of pride in being married to him. He was smart, funny, kind, successful, self-deprecating and handsome. It all sounded too good to be true but anyone who

knew him, who knew them, knew it was the real deal. She loved him and she loved being the girl he'd chosen, being half of their whole. They had it all. For a while, at least.

The changes happened over time. He began to appear distant and preoccupied. They didn't laugh like they used to. He would stay up late watching TV and fall asleep on the couch instead of coming to bed. He no longer wanted to go on hikes with her. She would ask him if something was wrong and he'd tell her, "No, you go. I'm just tired." He was becoming tired a lot.

♥ ♥ ♥ ♥

Less than two years after that, it was over. The truth had eventually come out, the trespasser had won, and their perfect life had been torpedoed. She had suspected there was something wrong, something going on, but not this, not to them. They were Teflon.

But in reality, they weren't so untouchable. They were mere mortals. Love hadn't conquered all and the idea that it could was bullshit, but she had bought into it hook, line and sinker. In a total of four years, start to finish, they had gone from being soulmates to just another shitty statistic. Four fucking years. That was it, that was her Happily Ever After. Now he was gone and he wasn't coming back. She wasn't a wife anymore, and even worse... she wasn't his wife anymore. He

was gone, the dog was gone, they'd had no children. She wasn't anyone's anything anymore, at least that's how she felt. It was just her alone in the house, and all she was left with was the aftermath, the rubble that is left behind when a war is over – and, as in all wars, there are casualties and there are those who are left behind to pick up the pieces.

She did all the things she was supposed to do to get on with her new life. She moved back to her hometown to get away from all the memories and to surround herself with friends and family. She'd gotten her own apartment, she went to therapy and talked about her feelings, and she found a job that she liked and was good at. Following the suggestion that she find positive outlets for her anger, she even started running again and lost the twenty-five pounds she'd put on when things had gotten bad and comfort food had taken on a whole new meaning. She did everything she was supposed to do – so why the hell wasn't it working? Years were passing by but still she couldn't let go and she hadn't moved on.

When she was alone, she would often slip back in time and disappear into a life that no longer existed. They were once the golden couple who everyone envied (or were nauseated by). They always wanted to be near each other. One night, at the home of a friend, the hostess thought it would make the dinner party conversation more fun and

interesting if she separated couples and sat strangers next to each other. Upon discovering this he gave her a wink, and when the hostess wasn't looking, they quietly laughed and switched their place cards so they would be dining side by side. Most everything was funny to them. They were always whispering and laughing over private jokes. They were always touching, even if it was just an elbow, or a finger absentmindedly tracing a sleeve. None of it was for show. They were that couple... So WHY? How could this happen? She turned it over and over and over in her mind.

She had been unable to let go of some of the mementos of the years they'd spent together, little bits of physical evidence that they were once so happy. She kept their wedding bands in a tiny black velveteen pouch hidden in the back corner of a drawer behind the unused socks that, like her, were worn thin or had no mate. There were pictures. There was a small cedar box that she kept in the shadows, shoved behind the DVDs in the cabinet underneath the TV. Inside it were some old coins, army medals, expired IDs and an old safety deposit box key from a bank that had long since gone under – meaningless things that he'd left behind and was never coming back to collect. Little trophies that she'd hung onto, either because they were tangible proof that she hadn't just imagined it all, or they were just too hard to dispose of (I mean, what was she supposed to do, just throw

them in the *trash*?) – maybe a little of both.

She carried around some invisible mementos, too, whether she liked it or not. Memory and experience lack any physical shape or weight, yet their emotional heft can be enormous. Like an invisible ball and chain cuffed around an ankle, or an anchor tied around her neck, they went where she went: Step, step, drag. Step, step, drag... The cause may have been imperceptible to those around her but the effect it had was not.

When he left her, she was gutted. It turns out that's not just a figure of speech, it seems he must have actually taken parts of her body with him when he went and their absence became more pronounced over time. He must have taken parts of her lungs because they seemed smaller and no longer capable of filling fully with air. He must have taken some of her vertebrae because she no longer boasted the beautiful erect posture which used to bring her compliments from friends and strangers alike. What he'd left of her heart was small and black and pulled so far back inside of her it left an empty space in her ribcage that collapsed her chest and rounded her shoulders forward.

She would think about their wedding. The ceremony, the celebration that followed. They had exchanged rings and vows and promises of forever. The usual pomp and circumstance of two people joining their lives together and making

it official in front of family, friends, church and state. But because there was nothing to mark the ending and give her closure, or more specifically, to commemorate the new beginning, it had left her feeling stuck, abandoned, and living in limbo. This pissed her off. Everybody made such a big effing stink when couples got married, so why wasn't there something that symbolized the transition back to living alone? I mean, Jesus, just look at the statistics. There should be something besides the documents unceremoniously spit out by the lawyers and the courts. Why was it that, in stark contrast to a wedding, the opposite of marriage was simply skulking off in heartbreak and defeat, holding the proverbial bag filled with your confusion, rage and your idiotic hopes and dreams, asking yourself how you could have been so fucking stupid and... now what?

She simply couldn't bear to go on this way. She needed to jar herself loose from the trauma, needed some sort of intervention or exorcism to expel the pain once and for all. And necessity, as they say, is the mother of invention.

What she needed, she decided, was another ceremony. Not like a wedding. There was no cause for dancing or confetti, that would be false and forced and unfitting of the occasion. What she needed was something solemn and reverent that would officially usher her through the process of letting go; a rite of passage. That was it! That's

exactly what she had to do! God, it was so obvious – why the hell hadn't she thought of this before?

Once born, the plan came into her head nearly fully formed, the details blossoming effortlessly. She knew exactly what to do, how it would look, where it would take place and, most especially, she knew exactly *when* it needed to take place. Oh my God, it was PERFECT! And there was only one person in the entire world she needed to make this happen. She needed Betty.

Betty had been a dear friend for most of her adult life and the only person she could bear to call when her world had started to crumble. Betty was, among many other things, a Justice of the Peace and – here's the key – she had been the officiant at their wedding. It was a perfect plan.

Although you might not hear from her for months, Betty was the type of person you knew you could count on, one who would drop everything and move mountains to come to the aid of a friend in need. So, the biggest challenge, really the only challenge, would be getting Betty to pick up the damn phone. Betty had a to-do list that was so esoteric and elevated, so steeped in community, nature and the arts, that she put all the rest to shame. She had political committees, museum docent duties, outdoor sports, nature classes (she taught), nature walks (she led), birdwatching, volunteer work, a house, a garden (flowers and veg-

gies), a new business, plus her husband and her beloved dogs to attend to (though not necessarily in that order). She also had a daughter in elementary school who required transportation to and from a list of extracurricular activities that rivaled her mothers. Needless to say, she was near impossible to get hold of. Let the phone tag begin.

She pulled up Betty's name in the contact list on her phone, tapped it with the tip of her finger and, as expected, the phone rang, and rang, and rang... "Fuck. I'm going to voicemail."

"Hey there stranger!" Betty said.
"Betty? Oh my God, is it really you? It's like a miracle!" She was only half joking.
"I know, right?" Betty said, "well, truth be told, I am, literally, walking out the door and I have, like, thirty seconds but I saw it was you and I had to at least say hi! It's been forever!"
"I know! I'm sorry I haven't called but, oh, my God, I'm so glad I got you."
"Me too! How are you?" Betty asked.
"I'm good. But there's a reason I'm calling... I need a favor."
"For you? Anything!" Betty said. Then, lowering her voice and a bit more seriously she asked, "are you ok?"
"I'm fine. I mean, not really. I will be! But I need your help."
"Alright, tell me what I can do," Betty said.
"OK, so, I'm doing the best I can but you know

I haven't been particularly successful in letting go of my marriage or, quote unquote, 'moving on', as they say," she made half an air quote with her free hand. "I don't really go out... well, OK, fine, that's totally normal for me... but I feel like I'm just carrying the weight of this thing around with me. When I'm around other people I try to act like I'm happy and that everything's great but it's not. I feel empty and stuck and it's been an embarrassingly long time and I've got to get over it. But you know all this, right?"

"I know, sweetie," Betty said softly.

"I feel like I need to DO something to get past it."

"OK, great. What do you want to do?" Betty asked.

"OK, so... here's the thing." She stumbled, unable to find the words, "I feel like I need to get... um... oh, shit, I don't even know what to call it! I feel like I need to get... un-married, I guess. I need to have a ceremony."

Hearing this, Betty placed her fingers lightly over her lips, closed her eyes and quietly sighed. She moved her hand away from her mouth and placed it gently over her heart and whispered, "Oh honey... of course you do." Because Betty instantly understood. She knew her friend so well, she knew her pain, and as the comprehension washed over her, she knew that there was something she could do to help ease her suffering and this was it. "Just tell me what to do."

Her clarity in what needed to occur took over. She took a deep breath and then just started talking: "I want to go down to the river, down past the dam in C-Ville, just you and me. I want to sit on the rocks and I want you to say a few words about letting go and moving on. I need to honor the time he and I spent together and I need to honor and acknowledge that it's gone and that it's time to let it go. I need to embrace the fact that it's MY time now."

"YES!" Betty interjected.

"Then I want us to sit there, listening to the birds and the water and I want us to drink some tea, and then I need to jump in the river and swim. I know it sounds crazy but I need to do it and I can't do it without you."

"Oh, honey. It doesn't sound crazy at all. It sounds beautiful and of COURSE I will help you! When do we to do this?"

"Well, I know it's short notice, and I know how busy you are, but Wednesday the thirteenth is the ten-year anniversary, if you can fucking believe that. I feel like it has to be then." Then, a bit sheepishly, she added, "You can pick the time."

"Of course, it has to be then! Let me see if I have to rearrange a few things and I'll get back to you later today with the time, OK?"

"OK! Oh my God, thank you so, so much! I need this so bad and I knew you'd get it!"

"I totally get it," Betty said, "this is a wonderful

idea. We are doing this, and I've gotta GO! I'll call you tonight, OK?"

"OK. YES! Go, GO! Thank you! I love you!"

"Love you, too."

So, it was set. On the ten-year anniversary, they each drove to the meeting spot in the tiny village. Carved into the thick woods and situated on the banks of a small river, it was a nature lover's paradise and they both knew it well. They met in at one o'clock in the afternoon in the dirt parking lot right near the kayak launch. When they saw each other, they smiled big and pure, got out of their cars and hugged. They each turned and grabbed a canvas tote bag from their cars, locked up, and headed off with quiet intention. The air was heavy with humidity, and its thickness, combined with the late summer density of the trees, helped to dull the sounds of the occasional car on the road and somehow added to the solemnity of the day. Without saying too much, they walked down the bike path and across the old trestle bridge over the river, before disappearing into the trees.

There was no one else in sight. The woods seemed heavy and sleepy in the sultry August afternoon and, under the alternating crescendos and drones of the cicadas hiding somewhere in the canopy of the trees, they walked on. They eventually left the pavement of the bike path and carefully picked their way, single file, down one of the loose dirt trails, deeper into the woods and down

to the riverbank. It hadn't rained in several days, or maybe a week, so the river wasn't too high, leaving plenty of room to spread out on top of the large, smooth rocks that peppered the banks and bed of the river.

When they arrived, she stood at the river's edge for a moment and watched as the water elegantly danced and swayed through the corridor of trees. Waltzing its way through the broad, elongated clearing of maple, birch, oak and pine, the moving water dipping and turning pirouettes around the rocks and boulders, leaving tiny dimpled whirlpools in its wake, and mirroring back the sunshine. She knew then that she had stayed too long away from the water and the woods. She was finally beginning to breathe.

The two women started to unpack their bags. Betty had with her the words she had written for the ceremony on two printed pages, along with two white tealight candles and two clear glass holders to put them in, matches, a few fresh flowers from her garden, a small, gray thermos of tea and two small cups. She placed it all on the smooth, warm rocks where they sat. The other bag contained the sacred objects from her past – the tiny pouch holding the wedding rings, a copy of the marriage license and, since she had only worn a giant, baggy T-shirt over her bathing suit, she had brought along a towel and some dry clothes to change into afterward. They had dis-

cussed the importance of having the Four Elements for the ceremony: Earth to ground them, fire to transform, water to cleanse and air to breathe. Betty brought the candles and matches, Mother Nature provided the rest.

They began by lighting the candles. Facing each other, sitting cross legged on the rock, Betty read the new vows of acknowledgement, acceptance and release. As she listened to Betty's words her heart filled and emptied a dozen times. Her eyes welled up and tears spilled out. They were tears of loss, heartbreak and regret. She cried for the love that was lost. She cried for the loss of the man she had loved so deeply and for the dreams they'd once had. She cried because her marriage was gone forever. She cried for the hellishly cruel way it had been ripped away and for the agony she had endured in being forced to watch it happen. She cried over the loss of the life they'd planned together. Then, as she listened to the loving words that Betty had written and the way those words evolved, she started to smile a sad smile – and she cried because she realized that along the way, she had become a hollow shell and had lost the fullness of a well lived life. For so many years she'd been stuck in the past and, instead of being a process, her grief had become a way of life because, although it kept her miserable, it had also kept her safe. It kept her from taking chances, from putting herself out there and exposing her raw, battered

heart to the world. She had hidden inside the pain, licking her wounds, choosing to allow the hurt of her past to shield her from the possibility of injury in the future. She hadn't known she was doing it, but now she did.

In that moment of epiphany, she understood that denial and awareness are mutually exclusive and cannot coexist. Her defense mechanism, her protective armor, the thing that had once kept her safe had, over time, itself become the burden.

Soon she was crying because she could feel herself letting it all go. She could almost feel it slide off her back like a suffocating shell she had long outgrown. Now, sitting on the rocks, she could be still and safe in the present moment. There in the water, she would wash herself clean and leave it all behind. Here in the woods, she could find the girl she once was before all the pain had changed her, and reconnect to the woman she is going to become. She was finally ready.

She breathed in and allowed the air to fill her chest, sat up tall, lifted her chin and pushed her shoulders back. With every breath she could feel the life force flowing back into her and feel her physical body expand.

She reached over with her right hand and picked the wedding rings up off the rock, placing them slowly in the palm of her left, then cupping them in both hands. Carefully cradling the

rings, she put her feet in the river, squatted down and placed her hands into the water. She held the rings in the space between her palms under the cold, moving waters and she felt them softly tumble. She closed her eyes and breathed deeply as she rubbed the rings back and forth between her palms and imagined all the dark, heavy energy being washed away, then she lifted them out, dabbed them dry on her towel and tucked them lovingly back into the little black velveteen bag.

She took the copy of her marriage license and stuck the corner of it into the flame of the candle. She held it steady to let it ignite and watched as the flames slowly crept across its surface and begin to burn... not out of anger but out of pure, calm, release. Fire transforms. She let it burn, acknowledging the process of the paper turning into flames, the flames turning into smoke, and the smoke dissipating into the air. Holding onto it for as long as she could, then dropping it into the water and letting it go. They watched as the water carried it away, extinguishing what was left of the flames and swallowing up the last bits of ash. Taking the flowers that Betty had cut from her garden, they tossed them in as well. Acknowledging their freshness and natural beauty and the way they had once burst forth from the warm earth, the way they lightly glided across the surface of the water, retracing the path that the burning paper had taken only seconds before. The symbolism of it all

was clear and the transformation had taken hold within her.

She and Betty looked each other in the eyes. She took a long, full breath in, sitting up tall and lengthening her torso as she felt her long-lost warrior rise up inside of her. She cracked a sideways smile and nodded her head slowly – because she knew that right here, right now, fuck yeah, she was taking back her power.

She took off her T-shirt revealing her swimsuit, then slowly, with intention, rose up off the rock, lowered her chin and narrowed her eyes... She was going in. She waded into the water up to her knees, then up to her thighs, opening her mouth and exhaling hard as she felt the cold water against her hot skin, but she didn't flinch. She kept going, up to her waist, then her ribs, and with a little jump up and a big breath in, dove head-first into the chilling water.

A desperately needed shock to the system, it literally, fabulously, *gloriously* took her breath away! The mid-August heat on her skin was instantly doused by the cold water and the crystalline air bubbles tickled her skin and gave her chills as they raced upward toward the surface. The feeling and sounds of the river surrounded her whole body and blew the cobwebs out of her brain and she could feel the distinct before and after! She had given her tears, heartache and grief away to

the river and it willingly took them from her. She wasn't empty, she wasn't broken, she wasn't abandoned, she wasn't trash that was left behind, and it wasn't her fault. There was nothing she had done to deserve that fate. Like a prisoner who had been wrongly convicted, her sentence was commuted, her unjust punishment was over and she was set free.

She swam down the five or six feet to the riverbed, bent her knees and pushed her feet off the sandy, stony bottom and burst out from under the water into the sunshine and screamed with delight at the cold. She looked at Betty and squealed and laughed, "It's cold!" Betty was laughing and clapping for her. She yelled to Betty, "What's-a-matter? Aren't cha comin' in?" Betty laughed and said, "Oh, hell, no! This is all you, baby!" She called Betty a chicken shit, which, of course she wasn't… she was just having way too much fun watching her silly, wise-ass, friend reappear right before her eyes. She smiled, took a deep breath and, without a word, plunged back down under again.

Feeling like a siren, she swam underwater, bubbles clinging to her skin and streaming out of her nose in a strand of glassy pearls. She laughed to herself as a scene from O Brother Where Art Thou popped into her head: "Preacher says, all my sins are warshed away!". She could picture Delmar as clear as day. It was OK to laugh again and mean it.

She was free to live her life and she didn't have to stay caged up and hidden to be safe.

She swam back to the shallow, stony bank of the river and rose up out of the water. As she stood up, she shivered but she was smiling. Actually, no, she wasn't just smiling, she was glowing. She grabbed her towel and wrapped it around herself and went back to sit on the warm rock. Betty poured them each a cup of the hot tea, one of her special blends of Gunpowder Green and God knows what else but, befitting of the day, it packed a highly caffeinated wallop.

The two women raised their cups and toasted their friendship, to long beautiful summer days by the river and of course, they toasted to the future.

CHAPTER FIVE
Birds of a Feather

Like attracts like.
Water seeks its own level.
We attract the love we feel we deserve.

They must have seen her coming. Sniffed out an easy mark like a lion hunting a wounded antelope. For the predatory male, the womanizer, it was the dating equivalent of Darwinism; natural selection, culling the herd, picking off the slow and the weak so they would be easy to catch and wouldn't put up much of a fight. For these men, strong, self-assured women were a waste of time and energy. They could see him coming from a mile away.

But not the broken-hearted women. They were easy prey, you just had to be careful not to spook them. Because they are wounded, they can be especially skittish – "once bitten, twice shy" and all.

You had to creep up slowly, no sudden moves, take your time, get them to trust you. It wasn't that hard. They were like abused animals at the pound, cowering in the corner but so desperate to have someone love them that they'd respond to any soft voice or the tiniest bit of kindness. Even if they didn't entirely trust you, the attention felt so good and they wanted it so bad that they'd ignore their own natural instinct to run. "*Here, kitty, kitty, I won't hurt you.*"

Over the past six or seven years she had engaged in a sorry trio of relationships, each man sharing the common trait of being entirely untrustworthy but possessing the loathsome ability of saying exactly what was needed to lure her in. His low self-esteem required that he prove himself as a man, over and over, at the expense of a woman whose low self-esteem required she be proven worthy of his attention. Like heat-seeking missiles, they'd find each other in a crowd. The men she chose were so similar they hardly bear individual mention. They were a "type": Smart, good looking, charming, lying, cheating, manipulative, verbally and emotionally abusive, and she was attracting them and allowing them to wreak havoc in her life.

She had known they were a bad idea before she ever got involved with these men. She remembered driving to a first date with one of them and knowing she didn't want to go, she wanted to turn

the car around and go home. There were alarm bells going off in her head and an uneasiness in her stomach. She had seen the red flags and the warning signs and yet, like always, she either chose to ignore them or talked herself around them. "Maybe I'm wrong," she'd tell herself, "maybe I should give him the benefit of the doubt. If I walk away now, I could miss out on a great guy! Maybe he just hasn't met the right girl!" And, once again, like a lonesome, needy, gullible idiot, she didn't turn the car around, she went to meet him anyway.

The relationships were all the same, a toxic breeding ground for dysfunction and chaos. After an extremely brief honeymoon phase it would quickly deteriorate, continuing for far too long until, like all noxious environments, it would inevitably self-destruct and incinerate.

Each relationship ended in ways that were stereotypical to the breed and entirely unattractive. Loud, undignified, rife with drama and in stark contrast to the woman she said she was (but right on target with the hidden, deep-seated belief of what she felt she deserved).

There was the one that came to a humiliating, public, verbal assault of an ending. She sat in her car staring at her hands on the steering wheel while he stood outside, hurling insults and obscenities at her through the open window at the

top of his lungs. Her only response was to cringe and whisper, "Please lower your voice, people are staring," waiting until he was finished before she finally drove away.

There was the one that ended after yet another night of him sitting alone in the dark playing video games and looking at pictures of women online until 2 am, followed by yet another morning of him disrespecting and belittling her. Exactly the same as a hundred other nights and mornings. But that day, something inside her snapped. As soon as he'd left for work, she gathered all his belongings, piled them in the driveway, changed the lock on the front door and put all of her things back exactly where they'd been before he'd moved in... like it never happened. He was a pathetic, parasitic, manbaby she'd met on the rebound and she was sick to death of him. She called him on his lunch break and told him to come after work and pick up his shit by 6 pm or she'd take it to the dump: "It's done," she told him. "Don't come to the door, just get your shit off my property, get the fuck out and don't ever come back. You can mail me the fucking money you owe me, have your daddy write a check." She had fantasized about doing it for months.

The worst of them came last, her emotional rock bottom. Like the others, he had a charming and polished façade but her every instinct told her something was way off with him. She wasn't hear-

ing warning bells in her head – she was hearing a blaring, full blown, submarine dive alarm. She had backed away and tried to end it over and over. Yet over and over she allowed him to bullshit his way back in. *("Maybe I'm wrong." "Maybe I should give him the benefit of the doubt." "Maybe he's a great guy!")* He turned out to be so vile a human being, so morally bankrupt and repugnant, that a clinical diagnosis of narcissistic sociopath wouldn't have surprised her in the least. He was devoid of conscience, he used people for his own amusement and showed no regard for the consequences of his behavior. The moment she fully discovered what he was she could no longer deny how far out of control her life had spun. There was nothing left for her to do but to bring everything to an immediate, screeching halt.

How did she get here? What the hell was she thinking? How had she let this happen? She seriously questioned her own sanity. She felt repulsed and disgusted by the choices she'd made, and the awareness terrified her, crashed in on her and brought her to her knees.

"What is wrong with you?" she asked herself, "Jesus Christ, are you really that stupid and desperate?" She thought about these men and how they treated her. How she had *let* them treat her. She thought about all the bullshit she'd put up with. She *knew* how badly they treated women and she had stayed with them anyway. They

were liars and cheaters and they treated her like crap, and she stayed with them anyway! Oh my God, why the hell would she ever get involved with them in the first place? Why? She covered her head with her hands and cried out, "WHAT IS WRONG WITH YOU? You must be fucking delusional!"

Her self-hatred rose up like bile. "Are you really that fucking lonely? Are you that gullible? You stupid fucking IDIOT! You did this to YOURSELF! YOU did this! You're fucking pathetic! Stupid, fucking, pathetic bitch! Why would you do this? WHY? WHAT THE FUCK IS WRONG WITH YOU?"

She berated herself until she dissolved into convulsive tears. She was bewildered and disgusted with her own behavior. But the awful names she called herself spoke volumes about how she allowed herself to be treated. If she spoke to herself this way, why wouldn't she let others do the same? It's how she saw herself and therefore what she felt she deserved. She was so ashamed she felt sick to her stomach but she was finally opening her eyes and being honest with herself, taking ownership of her reality. She was her own worst enemy. No one had forced her into this. No one held a gun to her head. She wasn't their victim, she was an active participant. The admission of the truth was demoralizing and heartbreaking.

For hours, she stayed curled up in a ball on the

couch. Wrapped in a blanket and surrounded by a mountain of snotty tissues, she looked back on the totality of it all and she sobbed. It wasn't so much that the relationships were over and now she was alone, it wasn't even that men like this were out there, she was an intelligent woman and she knew that. She cried because she knew this was entirely her own doing. She was the one who had allowed them into her life and, for years, had allowed herself to be treated like garbage by men who weren't even worthy of knowing her name. She had consistently chosen them over herself. She forced herself to look at the truth. She cried so hard she nearly threw up.

But this breakdown wasn't her low point; it was her tipping point, the catalyst to her breakthrough. She could either take responsibility for her choices and put a stop to it right now or allow it to continue, it had to be one or the other.

Eventually, she stopped beating herself up. She came to realize she was in trouble and self-flagellation wasn't going to solve anything – in fact, it was part of the problem. "What if you saw your best friend doing this?" she asked herself. "What would you say to her and how would you say it?" It was time she started acting like her own best friend. She forced herself to get up off the couch, walk into the bathroom, stand in front of the mirror, look herself in the eyes, and say softly, but out loud: "Honey, something is very wrong here.

What is it? What is making you to feel so bad about yourself that you somehow believe this is what you deserve? Whatever it is, you need to figure it out, however long that takes, and then you need to decide how you're going to fix it, because THIS is unacceptable, and it stops now."

What she saw in her reflection was the puffy, snot covered, tearstained face of a desolate and broken soul. She needed kindness, understanding and healing... and she needed help. She needed to do more than merely stop the behavior, she needed to find the break; the *cause* of the behavior. Right then and there, she made it her mission to discover how she'd gotten to such a place. Then she was going to help herself find her way back.

She did figure it out. It honestly wasn't that hard. She was quiet and she meditated. She took long walks and hot baths. She read and she wrote. She became very contemplative.

It was there in the peace and quiet where she was able to find the cause of her trouble. On closer examination, she would discover that the way she pretended to see herself and the façade she presented to the world had virtually nothing to do with what she truly, deep down, believed about herself. She found that this task of self-discovery didn't require digging deep down inside herself or peeling back the layers; it was about acknowledging what she had been working so hard to deny,

push away and keep buried, and allowing it to rise to the surface. This wasn't something she had to go looking for because it had been chasing her all her life, nipping at her heels, trying to take her down and, despite her best efforts, it had finally succeeded. No, this truth wasn't something she needed to figure out, she only needed to stop running from it, turn around and face it. Then she needed to find the courage to sit quietly and really listen.

It was the hushed voice from deep within her that told her she was worthless and incompetent, that she was too stupid and inept to ever take proper care of herself, the one that told her nobody liked her and she wasn't good enough, that she was lazy and she sucked at everything. The voice that said she was going to make a fool of herself and, every time she tried something new, would ask her, *"Who do you think you are?"* The voice that told her she was a giant fraud and that, sooner or later, everybody was going to find out, it was really just a matter of time. She had to force herself to sit quietly, screw up the courage to turn up the volume and, after all these years, finally listen to what that terrible, cruel voice had to say.

She discovered that because she had so desperately tried to silence that voice and push it away, she had, in essence, sent out a casting call to the Universe. It had sent her people who would voice these beliefs to her face. This is how you feel

about yourself so here are some people who think it, too. They will treat you how you feel you deserve to be treated, deep down inside. They are reflections of your own self-worth. Real human beings who will act out these feelings because, one way or another, be it internally or externally, those self-held beliefs will be heard because they had something to teach her.

The fact that the people she had allowed into her life were the embodiment of her deepest fears about herself could not possibly be a coincidence. I mean, c'mon, these assholes were not only treating her like she was worthless, not good enough and didn't matter, sometimes they were literally screaming it at her while she sat in her car, engine running, and listened. Why the hell else would she have just sat there cringing and let her jackass ex-boyfriend finish his barrage of verbal abuse, telling her, in so many words, that she was a fuck-up and that his needs and feeling were vastly more important than hers, unless she thought she deserved it? She could have told him to shut the fuck up! She could have told him that NOBODY had the right to speak to her that way! She could have just driven away! She could have told him to take a hike the moment she met him. But she didn't. She got involved with him. And when he was standing outside of her car screaming at her in a crowded parking lot, she asked him to please lower his voice. Not to stop talking, but, instead, to abuse

her in a quieter tone and then she sat there until he finished. He was a life-sized manifestation of the low self-esteem that she thought was so neatly hidden away.

"Wow! Good work! Massive realization! What a breakthrough!" she told herself.

But now what? She needed to deconstruct those negative beliefs and dissolve them, replacing them with a new empowering internal narrative.

Once she figured out that the people in her life were mirrors, a reflection of how she saw herself, she needed to figure out why she felt this way. She needed to get to the core of the issue. She decided it didn't matter how these feelings got there or who had originally put them there to begin with – they were hers now. She had taken ownership of them long ago and she was the one responsible for continuing to give them life. Now it was her responsibility to get to the bottom of it.

She had discovered that at the core of her beliefs, fears and insecurities, she was "not enough". She also discovered that this belief most clearly manifested in two areas in her life: The first direct result of her insecurities was a lack of money, as in "not enough". She worked hard but was always broke. Her house was in disrepair and she was behind on all her bills, which filled her with shame and reinforced her low self-worth. The second

place these beliefs and insecurities showed up was in her toxic relationships. She had low self-esteem and she felt like crap about herself. She deduced that her male counterparts, also having low self-esteem, probably felt like crap about themselves – and if like attracts like, then crap attracts crap. Based on this awareness she developed a three-pronged plan.

Rule Number One: No relationships of any kind with men for one year. None. No dates, no flirting, no phone calls, not even hanging out platonically with male friends (because they also offered attention and externally fed her damaged ego). It was absolute. No relationships. No men. Period. They were part of the problem and also a distraction and she could afford neither, so they were the first thing to go. She was officially and completely off the market.

Rule Number Two: Focus inward and practice self-care. She'd never really developed a true sense of self or figured out who she was as an individual. She needed to get to know herself and to be entirely autonomous. She would also be kind to herself, practice self-respect, maintain a healthy lifestyle, and there would be no more negative self-talk. She would stop putting herself down or calling herself bad names. Like her mother taught her, if she didn't have anything nice to say, she should say nothing at all. If she was going to change the way she felt about herself, she

needed to treat herself like she was important and worthy, and she needed to rewrite her internal dialogue.

Rule Number Three: Career. Years ago, she had chosen to work in a field that she loved but had never really enjoyed it. She would now allow herself to be fully focused on developing and nurturing her career, to let go of the parts of it she didn't love and to pursue and expand the parts she was passionate about, to continue her education and become an expert in her field, to know her own worth and to claim it.

That was it, simple but not necessarily easy. The entire year was devoted to helping herself heal; mind, body, spirit and craft.

She embarked upon her journey of solitude, self-awareness and raising her own self-worth. She threw herself into her career, doing the work she loved. When she wasn't working, she was on a mandatory, self-imposed retreat. Once she committed to the process, she felt a true sense of calm and purpose and an enormous sense of relief. Eventually the sadness left her, and she began to enjoy herself and to become happy from the inside for the first time in her life.

She was amazed at how much time and space she discovered in her life when she cast out all the clutter, and all that time and space was hers, alone, to do with as she pleased. She got up at

dawn and went running, she hiked, she practiced yoga and meditation, she swam in the creek near her house and spent time in nature. She shut off her cable and stopped watching the news. Instead, she went to the library and checked out books, movies and books on CD about empowered women and people who had risen above and defied the odds. She purged, decluttered and organized her little home. She painted the walls, got some repairs done or did them herself, and she kept it clean, calm and tidy. She shopped at local farms, picked her own vegetables, berries, apples and peaches, and she prepared and ate the food that she liked and was good for her. She pursued her art again and was invited to have her first art show. She read books and she went to bed at the time that best suited her. What little time she did spend socializing, was spent only with one or two of her very best girlfriends who were on similar paths; they fully understood and supported one another and they cheered each other on. She created a life that she never even knew she wanted and she fell in love with that life. She even began to love herself and grew to enjoy her own company best of all.

The year passed. As she looked back, she was astonished at how far she had come, how much she had accomplished and how much she had enjoyed it, and she knew she wasn't done yet. She smiled and thought to herself, "If I can do this

much in only one year, imagine what I can accomplish in two...

CHAPTER SIX
Ghost in the Machine

Suspicion; It was her first language. Programed deep into her subconscious at a very early age, it had become the mechanism of translation and the filter through which all incoming information was processed. But for the past several years she'd spent an increasing amount of time in the self-help section of the book store, and every weekday afternoon watching informative talk shows. It's where she'd learned about the power of intention and why she now kept a gratitude journal. All the while, the new information, like droplets of water on thirsty seeds, conspired to germinate change. Tiny roots coaxing fissures in her psyche. And so, she'd had a creeping awareness of what she'd been doing – distorting the facts, creating negative outcomes, accepting her imaginary worst-case scenarios as reality and allowing them to make her really

angry, and she'd begun to try to stop herself. She'd tell herself she was jumping to conclusions and that it wasn't real, she was literally making up stories in her head and having a physical reaction to them. That was crazy, wasn't it? Yes. But the mind is a powerful and convincing storyteller and it is relentless.

She looked at the clock on the stove. 5:40 pm. Ten minutes late.

She busied herself in the kitchen making dinner, cleaning up as she went along. She hated disorder and found it nearly impossible to function with crap everywhere. Like a lot of things, a mess stressed her out. Keeping the area free of clutter helped her to feel calm and more in control of her surroundings, especially when, as is currently the case, her surroundings are somewhat compact. Corralled within a ten by ten-foot square, it was a well laid out and efficient work triangle and little else. Refrigerator on the wall to her right, stove on the wall to her left, a double sink in the middle with a window over it and about three and a half feet of counterspace on either side, dishwasher down and to the right. Standard condo issue. Contractor grade oak cabinetry, walls and countertops in a neutral and uninspired shade of beige but probably called something like "Sahara Bisque" by the vendor. They plan on redoing at some point it but it's perfectly serviceable, so it can wait. She looked at the clock. 5:41.

She peeled four big potatoes, rinsed them under cold water, cut them into large cubes and put them in a big old pot that she loved. A soft breeze through the open window filled the curtains with warm air, making the edges hover and wave like butterfly wings as it made its escape. She looked out into the tiny, half-full driveway, just big enough for two cars. Her eyes moved across the sun dappled front yard and down the empty maple lined street. She put the pot into the clean side of the sink and covered the potatoes with cool water from the tap. Turning and placing the pot on the big burner at the back of the stove, she set the dial to high and looked at the clock. 5:46. Sixteen minutes late. She took a slow intentional breath in and out to steady her nerves - and to keep her phantasmal wolves at bay. But still, they were becoming restless. Anxious to be loosed, they were starting to whine and pace in her brain.

She turned back to the sink and grabbed a handful of the narrow, cast off strips of potato skin, glanced out the window and dropped the skins into the trash, and then did it again; sink, skins, window, trash. She tore off a couple of paper towels and wiped up the translucent bits of potato that remained, folded the paper to trap them, and with the clean side of the towels she dried the sink. (*don't look at the clock*) She looked at the clock; 5:47. She looked out of the window. Noth-

ing.

She went to the stove (still 5:47) turned on the oven light and crouched down to look at the chicken roasting inside. It was just beginning to brown nicely and the juices were bubbling away. It was a big bird, enough for dinner tonight plus plenty of leftovers. That'll be nice. It'll smell good when (*if*) he (*ever*) gets (*the hell*) home. She turned off the light and looked at the clock. 5:48 pm. She stood at the window and watched, curtains breathing, the late day air of early summer, warmer outside than in, caressing her bare forearms and nudging wisps of hair. She listened for a car. Nothing. No big deal, she told herself and ignored the pit growing inside her stomach and, as though someone stood behind her languidly drawing in the strings of a corset, the gradual confinement of her breath.

She had to pee. Washing her hands in the bathroom sink, she looked at herself in the mirror. Red sweatpants (the stay at home woman's predecessor to yoga pants), and a blue and white long-sleeved baseball shirt that read "Property of the Los Angeles Dodgers", sleeves shoved up above her elbows. Several hours ago, she had pulled her thick wavy hair up into a pony tail but it had since disintegrated into an unruly, disheveled mess. The bathroom door hung open wide and the argent backlight cast upon her from the picture window directly behind, revealed the amber halo

of frizz that perpetually surrounded her head, like the mist rising off Niagara Falls but far less enchanting. Brushing it would only make it worse. She sighed, slowly taking herself in, considering the possibilities. She looked as though she had either gotten dressed in the dark, was a really patriotic (and possibly unbalanced) baseball fan or had simply given up on trying to look good. Her eyes made their way to her face. "Oh my God. Really?" she said aloud, "I'm, like, four hundred years old and I have a zit?" (She was actually 40 years old and she actually did have a zit.) She pursed her lips at her reflection and breathed out hard through her nose. To compensate for the pimple, she momentarily considered changing into "real" pants but, ugh, then she'd have to sit down and eat in them and she was so comfortable right now. It's hot out, she thought. I suppose I could put on a cute top and some shorts, not that my ass is ready to make her summer debut. And he's going to crank the AC down to fifty below the second he walks in the door, so it's not my fault if I have to dress like a dang Eskimo to keep from freezing to death in the middle of summer. Pfft. Screw it. Besides, he likes it when I'm tousled and casual. He's the only one who gets to see me like this! HA! Now, there's a real win for intimacy! Could be worse, I could still be in my bathrobe. I could have hairy legs, white sweat socks and Birkenstocks. Or Crocs! And a scrunchy! Yep, could be a lot worse. She smiled at her own facetiousness and

walked back to the kitchen. It's a mighty fine line between being comfortable in your own skin and not giving a shit, she mused.

It was a beautiful June day and at 5:52 pm it was still as bright as noon, which probably made it feel less late. (Twenty-two minutes late.)

No big deal, she brushed it off.

About thirty seconds later, she looked at the clock again (5:53) and reminded herself that he was a good man, he loved her, and it didn't mean anything. He'd never hurt her, nor was he lying somewhere on the side of the road in a ditch or anything like that. Everything was fine. After all, when she used to work, it would invariably happen; just as the day was winding down, she'd get stuck on the phone with a client, then on the drive home she'd hit traffic and every single red light. Despite her best intentions, by the time she arrived she was sometimes forty mins late. It happens. There. That's all it is, she told herself, appeased by her fleeting reprieve.

Until it dawned on her. If she was *telling* herself that everything was fine, there was a reason – it meant she didn't really think *nothing* of his tardiness. If it truly meant nothing to her, she wouldn't be turning this all around in her head. Yet there she was, obsessing over the time and trying to reassure and pacify herself. It hit her that the act of consciously and intentionally telling herself it

was nothing was a clear indication that it wasn't. Damn. Sometimes she really hated this self-realization shit.

As she gazed out of the kitchen window lost in thought, her sixteen-year-old neighbor came into view and headed straight for her. For years she would just turn up, never knocking or waiting to be invited in. She felt a little sad for the girl. She was sweet and awkward, funny and shy, and though she was a bit of a smartass there was an underlying sadness about her; she seemed lonesome. But why did this kid always seem to materialize when she was freaking agitated or just needed to think?

The girl fluttered in like the breeze, flopped down like a chicken coming to roost, making herself right at home. In addition to her uncanny talent for appearing at the most inopportune moments, she talked incessantly, had no filter, and never seemed to know when to shut up.

"It's just you here?" the girl asked.
"For the moment." She turned the heat down on the potatoes, which had started boiling, looked at the clock, 5:56 pm, and set the timer for twenty minutes.
"I didn't see his car in the driveway, so I thought I'd come visit while you wait."
"That's nice," she said quietly. Turning her back to the girl, plugging the drain and filling the sink

with hot water, she slipped on her yellow rubber gloves, gave a long shot of dishwashing liquid and absentmindedly began to wash the last of the dishes from her dinner prep.

"He's late again?"

"Yeah," she said, "he's on his way. He'll be pulling in the driveway in any minute, now."

"Oh, he called?" the girl asked.

"No," she answered, trying not to sound hurt.

"Oh. Are you gonna call him?"

"No."

"He should have called," the girl said, "I mean, if he knew he was going to be late it would have been nice, right?"

"He's not that late. He's probably just stuck in traffic," she said.

"Maybe you should just call him."

She ignored the suggestion.

"You could pretend to be calling about something else. Maybe you can ask him to pick up dessert on his way home or something like that. Then he would tell you where he is and if he can stop."

"I don't want to call," she said quietly.

"Hmm," the girl said, and launched into yet another story about herself and her "so-called boyfriend". "So, speaking of guys being late, I told you what happened to me and my 'so-called boyfriend', right?"

"Yeah, I know the story," she said

"So, remember how we were going out, like, boyfriend girlfriend, for a long time? And remem-

ber how much I loved him and how he said he really loved me, too? Remember?"

She washed the dishes and tried to tune the girl out.

"I thought that we were really in love 'cause we were so happy. At least I thought we were," the girl continued, "but then a new girl moved here. You remember about the new girl? Yeah, you remember her, right? Anyway, I didn't like her at ALL... not from the moment I laid eyes on her. She was really pretty and she was kind of a show off and a little too friendly to my 'so-called boyfriend'. Anyway, I started getting a weird feeling because it seemed that more and more, whenever I found him, there she was, remember? Then one day he was late picking me up for a date and I waited and I waited... Do you know how it feels to just be sitting there waiting? Believing that he's on his way but not really knowing for sure where he is or if he's really even coming? Or wondering if maybe something bad happened to him? Yeah, that's right, it feels like fresh laid crap. And do you remember what happened?"

She just sighed, staring into the void through the kitchen window.

"He never showed up! I called him but there was no answer, so I finally just drove over to his house and there he was! He just blew me off! Said he 'forgot'! Yeah, right," the girl said, "he wouldn't even let me in the house! So of course, we got into a

huge fight right there in his driveway! I was like, 'Where were you? You were supposed to meet me! We had a date!' He just said, 'I don't know,' in this dumb, sad, assholey voice. I said, 'You didn't even call me! You hardly ever call me anymore!' And he just stood there staring at the ground! I said, 'What's wrong? Don't you love me anymore?' He wouldn't even look at me! He just shrugged his stupid scrawny shoulders and kicked at a rock or something. Idiot."

She hadn't wanted to hear the story again but she was getting caught up in it in spite of herself. Stirring unwelcome memories, she could feel the hurt and anger bubbling up. She slowly shook her head and said on her breath "Boys. They start early, don't they?". Her stomach and jaw tightening as she listened to the girl, who said quietly.

"It really broke my heart. I'll never forgive him. I'll never trust anybody ever again."

Listening to the girl and feeling her pain, she stared trancelike out of the window, her gloved hands in the warm, sudsy water, slowly washing the inside of the same bowl she'd been working on for about two minutes. She felt angry and resentful and although she didn't say it out loud, she thought that not trusting anyone is probably not such a bad idea.

"God. What a fool I was," the girl said, with equal parts sadness, anger and shame in her voice.

"It was such a long time ago," the woman whispered into the air, "this has nothing to do with anything right now. Why in the world are you still thinking about this?"

After a stewing on this for a moment, the girl continued her pessimistic soliloquy.

"There's a new girl working with your husband, right? In her early twenties? What's her name, Bethany? Something like that? I've seen her and, I hate to say it, but she's really pretty. She dresses really nice all the time, too, and she's not afraid to show off what's she's got, if ya know what I mean? It looks like she spends a lot of time getting ready for work because she looks so perfect and put together all the time, high heels and everything. That's what you used to do, remember? I remember. You used to spend time on yourself, making sure you looked pretty for him too, right? But that was before you stayed home so much. You said she's always asking him for advice and asking him to help her with things. Why would she do that? Doesn't she have a boyfriend? It seems like she likes him – and I bet he likes the attention!"

The woman was really starting to get angry. She did not want to think about this right now.

"Don't you think?" the girl insisted, "don't you think he probably likes the attention? Guys like it when pretty girls make them feel like they have

all the answers and can solve all their problems, don't they?"

"Yep. Sometimes they do," she responded.

"Do you think he likes her? Like… 'LIKES her' likes her? I mean, obviously he loves you, YOU'RE the one he MARRIED, right? But maybe he kind of likes her, too? NO! That's crazy. He doesn't like her. That's stupid. But I bet that won't stop her from trying. Maybe he's helping her do something right now. He's way too nice for his own good. Women can take that the wrong way if they want to. Or maybe they're still at the office, talking. He's way too polite to tell her to shut up 'cause he's gotta go and she's probably thinking 'oh he wants to stay here and talk to me because he likes me!'" the girl mocked, speaking in a baby voice, "maybe that's where he is. By now, everyone else they work with has gone home, don't you think? Oh, I bet she'd love that, wouldn't she? Getting him alone like that? She's probably coming on to him but acting all cute and innocent about it right now. HA! The little slut! Getting all flirty. I bet she's wearing something tight and low cut! Laughing at everything he says and leaning forward, reaching across to touch his arm. Crossing her arms to casually push her boobs together. Pfft! That old trick!"

"Stop it!" she snapped at the girl, "it's not like that at all!"

"Oh, yeah, sorry. You're right. It's not that. He's probably just stuck in traffic like you said. He probably hit traffic coming over the mountain. Hey, speaking of which, did you hear there were two more fatal crashes this week at the top of the mountain? I swear I heard sirens again a few minutes ago. Oh, God you don't think he...?"

She dropped the bowl into the water and threw the sponge. "Would you please just shut the hell up!" she shouted, surprised at the intensity of her outburst. *God! Where the hell is he? Please just get home!* She grabbed a dish towel and buried her face in it, water and suds dripping down her elbows and onto the floor.

Truth be told, this wasn't exactly what happened that late afternoon. It's close, but with one notable exception – the woman was all alone in the kitchen that day. The conversation was the same, but it was all in her head. There was no neighbor girl in there with her, she's merely an illustration. The girl represents the woman's internal dialogue, the endless loop of negative thoughts and memories that play over and over in her head that, no matter how hard she tries, she can't seem to turn off. They appear without warning, usually when she's anxious and fearful, and they remind her of how she was wronged in the past, warning her that people can't and shouldn't

be trusted because, given the slightest opportunity, they will hurt her again. The woman in the kitchen and the girl in the kitchen are the same person at different ages and the story of the girl and her "so-called boyfriend" is the woman's own teenage past come back to haunt her.

When she was young, she'd been lied to and cheated on by her first love, her first real high school boyfriend. She had suspected that something was wrong, that there was someone else but he'd assured her, over and over, that there wasn't. One day, when she'd confronted him after he'd stood her up for a date, they argued and he admitted that he didn't love her and he never had. Maybe he thought he did for a minute, or maybe that was just something he thought he was supposed to say to her but, either way, what he felt for her wasn't love. He finally admitted he'd met someone else that he really did love; he told her the comparison between his feelings for the two of them was how he knew the difference. He said he'd lied to her because he didn't want to hurt her. It didn't work. She was devastated.

Something very similar happened when she was a little older, and again in her late twenties. Each time, she thought she loved the man and thought he loved her, too. Each time, she suspected there was someone else and each time they'd assured her there wasn't. They'd told her she was insecure and paranoid. She wasn't, she

was perceptive; there'd been someone else, sometimes more than one. Boys, and later, men, had liked the way she looked and sometimes they'd lied to be near her. She had been sweet, naïve, far too sheltered and trusting, and she had a bad habit of overly investing herself and so, time and again, she'd end up broken hearted.

For some girls this was just a normal part of growing up. Of course, it hurt terribly, but eventually they'd let it go and leave it behind, chalk it up to experience. For others, like her, each broken heart left behind scar tissue and had a cumulative and eroding effect. She came to believe she was more trouble than she was worth and that, inevitably, they would tire of her and she would be traded in for a younger, prettier, sexier version of herself with fewer issues. Someone they could envision spending forever with. Someone who wasn't... her. She viewed the rejections as personal failures and like a shadow, they stuck to her and followed her around.

Tethered to the past, she viewed the present and the future through the same distorted lens. She was haunted by her memories and controlled by fear. The girl in the kitchen telling her story was the wounded, bitter voice that played in her head. Her sixteen, twenty-one, and twenty-six-year-old self, stuck on repeat, taking turns retelling whichever cautionary tale most readily dovetailed with the present scenario in some sort

of damaged warning system or self-preservation method gone awry. But now, instead of just revisiting the past, it had her convinced it was happening again, right now. And the wild tales it foretold, with their fabricated heartbreaking endings, she accepted as a foregone conclusion. It told her that the only predictor of the future is the past, and it is absolute. She could expect it and count on it. Her subconscious operating like a doomsday IF/THEN computer program: IF he is late THEN something is wrong. Period. She needn't wait to discover the current reality, she'd filled in the blanks and it was never going to be good. There was no room for logic or interpretation, no circumstance was judged on an individual basis, and there was no situational adjustment. Experience had taught her this is just how it is, all the time without exception. If it turned out she was wrong, she'd feel a huge relief. If it turned out she was right, well then, HA! She was right! She knew it! Either outcome had its payoff – and payoffs, even the twisted kind, always feel good.

But, consider this; if she was allowing something that happened when she was sixteen years old to affect how she saw things now, wasn't that the same as allowing some brokenhearted little neighborhood kid to follow her around telling her what to think and how to feel, demanding that she mustn't trust anyone? It was, indeed. She was allowing her emotions to be controlled by the ex-

periences of a sixteen-year-old girl. This was her truth and now she saw it.

But she wasn't a girl anymore, she was a grown woman with a home and a husband. A good man who'd done nothing wrong – but in about ten minutes, when he got home, he'd be greeted with a bad mood and an interrogation because her fear of the unknown was about to present itself as anger. "Where the hell were you? I thought something bad happened! I thought you were in an accident or... God knows what! Who were you with? Why didn't you call me?" Any attempt he made at defending himself was fruitless. After all, he was dealing with the emotional equivalent of a sixteen-year-old.

She tried to silence the damning revisionist dialogue that had him accused, tried and convicted of some hallucinatory crime, but it was too late, her imagination had bested her. She was unable to talk herself off the ledge. His sentence would be handed down the second he walked through the door and justice would be swift and severe. She'd done it before and they had argued. She was fearful, self-righteous, accusatory, aggressive and irrational; he was blindsided, hurt, confused, defensive, and soon, pissed off. Just because he was a few minutes late, why would the only possible explanation be that he was either dead or doing something wrong? "It's a pretty big goddamned leap!" he had told her.

She knew it was crazy but she couldn't seem to stop herself. The addiction to tumbling down into the bottomless pit of her inevitable affronts, and the subsequent anger they produced, was overpowering. It was like a drug and she needed a hit. It's how the subconscious and addiction work. If you keep repeating an action, if you can't or won't stop it despite your knowledge of its negative outcome, that's an addiction. Like most addictions, it had come full circle. What was once the salve or the solution to a problem eventually became the cause of the problem, and when what used to work doesn't work anymore, the behavior generally escalates.

In her conscious mind, she would justify her defensive posture by telling herself she wasn't going to allow herself be blindsided again. She needed him to know she was tough and she was nobody's fool! She was wise to what happens out in the world and she was watching him, so he'd better straighten up and fly right!

But it was all bullshit and bravado. He knew it and, eventually, she knew it too. She was ruled by fear and lashing out like a cornered animal and now it was backfiring on her big time. Her lack of faith was hurtful to him and it was pushing him away.

Maybe her insecurity was once a means to an end. She wanted him to convince her she was

wrong, but the game became very old to him very quickly and soon had the opposite effect. It went from, "Don't be silly, you know how much I love you." To, "REALLY? Are we going to go through this shit again?" She needed constant reassurance and it wasn't cute anymore. It was paranoid, insecure and really unattractive. She had become everything her ex-boyfriends had once accused her of. Instead of trusting her own instincts when she was younger, she had chosen to believe their lies – and now, she had become what she believed.

But all that she'd ever really wanted was to be loved and held close. She didn't want to have to be hard or tough, she wanted to feel safe and happy. She was so tired of keeping her guard up all the time, the fear was exhausting. She desperately wanted to trust and let go, and to fall back into waiting arms but she was terrified that, like so many times in her past, he wouldn't be there to catch her. She began to wonder, what would happen if she just told him all that? What would happen if, now that she was aware of what she was doing, she stopped trying to manipulate the situation to force an outcome? What if she just dropped her weapons, cut through all the bullshit and told him the truth? Her only known modus operandi was freaking crazy, completely immature and, worst of all, it wasn't working anymore – so, how about coming clean and simply asking for what she wanted in so many words? It had never

occurred to her before... and it might just be crazy enough to work.

But how? How does she rewrite her history? "If it were that simple, wouldn't I have already done it?" she asked herself, "well, not if I didn't know I was doing it, I guess." But could she just step out from behind the curtain and wave the white flag? She felt backed into a corner and didn't see much of a choice.

Her biggest fear was being abandoned again but her fearful behavior was driving him away. Cause and effect, it was real and she was actively making it happen, she could see that now. And as they say, "we create that which we fear the most". Knitting her brow and biting her lip, she paused and really thought about that for a minute.

"We create that which we fear the most," she said it out loud. Standing frozen, allowing the words to roll around and marinate in her brain. She could feel she was on the brink of unearthing something but didn't know quite what just yet, afraid to move or even to breathe, lest she scare it off. She repeated it slowly, giving each phrase, each word, space to blossom and expand. "*We create*... that which we *fear*... the *most*. We *create*... that which we fear *the most*. We create that which we... we create..." she trailed off. Then, as if she'd discovered the Rosetta Stone and cracked the code to the Hieroglyphs, her eyes and mouth

flew wide. "Wait a minute..." she whispered, "wait a minute... Wait just a goddamn minute!" She looked down at the dog who was looking back at her, head cocked, and she said, "Kasie? Are you thinkin' what I'm thinkin'?" Kasie wiggled and wagged her tail. "Yeah, that's a good girl!"

"I'm scared of losing him somehow, so I worry about it. My worry gets my imagination working overtime playing 'what if', the conclusions I jump to make me *mad* and I take it out on him, which is driving him away! Which is precisely what I'm afraid of! My fear, the crazy thoughts in my head, are exactly what's causing what I'm most afraid of! Oh my God! It's not him! It's *me*! I'm the one doing it! "Well, shit. That sucks. It's so much better when there's someone else to blame!" she told the dog.

"But, BUT, if I'm able to create my biggest *fear*, is it possible that I could take *all that energy* and use it to create my deepest... *desire*?

Her mouth was agape, she started to grin like the Cheshire Cat and she finally said, "Oh, you bet your sweet ass I can!" Instead of jumping all over him with accusations and demands the second he came through the door or, conversely, being pouty, moody and distant, repeatedly telling him "nothing is wrong", today she will force herself, *force herself*, to make a different choice.

On the cusp of discovery, she was excited,

scared and confused, not knowing whether to laugh or cry. After living so long in the dark, the lights were flipping on, one after another, and it was all coming at her so quickly! Did she really have a choice in this? If she did, she knew she wasn't ready to pull it off this second, she needed some space to wrap her brain around it first.

She stood there wringing her hands, not knowing where to go or what to do as her nerves overtook her. She felt as though she was about to get caught at the scene of a crime and needed to escape, to calm down and get some air, to process and *think*. Two minutes ago, she practically wanted to strangle him for something he hadn't even done, for God's sake. It was crazy.

She'd take the dog for a power walk. That's it. Thirty minutes. Fifteen minutes out and fifteen minutes back. She could do that, right? Instead of staying there, lying in wait for him, she could get out of the house, burn off the anxiety, get it out of her system, suss things out.

Leaving now went against everything she'd known, and with every fiber of her being she wanted to stay and wait for him, just so she would know when he was home, safe and sound. She couldn't *stand* not knowing. Leaving when she was like this, even for thirty minutes, she was a junkie leaving her fix. But she was doing damage and she wanted, *needed*, to make it stop. Fueled by

the exhilaration of the knowledge that she had the power to stop it, she got out a piece of paper and, faking ease and happiness, hand shaking, wrote him a note.

"It's so nice out, I took Kasie for a quick walk down to the river. There's a chicken in the oven and I'll be back before it's done. Back at 6:45, Dinner at 7! XO"

Just then the timer for the potatoes went off, nearly sending her straight through the roof. She quickly grabbed the colander from the cabinet, set it in the sink, snatched a couple of potholders and taking the pot off the stove she dumped the whole thing into the sieve and left it. She grabbed the pen and added "PS: Potatoes in the sink are HOT! Careful! Making mashed! YUM!" she added a smiley face and stuck the note on the fridge with a magnet.

She put the lead on the dog, strapped on her fanny pack, threw in her cell phone and keys and slipped out the front door. They cut around the back of the condo to a short trail through the woods, across the meadow to the dirt path along the river. But he still wasn't home. *Why isn't he home? Where is he?* She felt her heart pound as her anxiety surged. "It's not real" she told herself, "you're just making shit up in your head. Just breathe. He hasn't done anything wrong. Everything's fine. *He's* fine. You're OK. Well... I'm

clearly completely fucking nuts but other than that, everything's OK." Tears spilled over the rims of her eyes.

She walked fast, talking out loud to try to release the adrenaline, using her dog as a sounding board: "OK, this is crazy and I've really got to cut it out. Right? So, let's think about this rationally, get to the bottom of it, and come up with a plan of action. Wow, that's a whole lot of Oprah and Dr. Phil talking! Well, good. OK, so, I'm clearly acting out of fear. The fear is coming from crap that happened when I was young, and, now, I'm obviously afraid it's going to happen, or *is happening*, again. THAT is what's causing me to act out. I'm actually allowing myself to think and act this way because, well, before I didn't even realize I was doing it, but now, I'm just doing what I've always done because it's way easier than facing up to it and trying to stop it. *Way* easier. Man, changing is hard! But what's the alternative? Am I really going to continue to let a freaking sixteen-year-old boss me around? Really? Oh, hell no I'm not! That's insane."

Her pace didn't slow but her thoughts had started to clear and her breathing was a bit easier. She started thinking about what she could do differently.

If I'm just making up stories in my head, she thought, why not make up a different story? A

nice story? One with a happy ending. It would be really awesome if I didn't have to make up any stories at all but, hey, Rome wasn't built in a day. So, OK. What if, instead of making up some garbage about where he is, or tracking his imaginary steps my head, wondering if he's hurt, what if I imagined something more earthbound? Maybe he stopped for groceries on the way home? Maybe he needed to stop at the ATM or put gas in the car?

"What if I decided," she asked Kasie, "I wasn't so 'tough'? What if, instead of proving how 'tough' I am, I saw myself as 'strong' instead?"

After all, if somebody's 'tough' it implies that, whatever it is, you can 'take it' – but if you're strong, it says that you get to decide what you will or won't take.

"Yep, choosing to be strong is way better than needing to be tough," she decided, "I'm always so afraid and feel I need to prepared for the next bad thing. But honest to God, it makes absolutely no difference at all.

"Wait, that's not true!" she concluded. Her worry *was* changing things! "Waiting for the other shoe to drop doesn't make me safe, it's actually making things way worse!"

She was torturing herself with her negative thoughts. It certainly didn't change what he was doing when they weren't together, but when they were together, that sort of thinking usually ruined everything. "It's a self-fulfilling prophecy! Think-

ing things were going to be bad has actually made them bad!" And therein lay her power. "Wow! Look what I'm able to create! HA! I'm a powerful *sorceress*!" Now that she knew it, she would use it to her advantage.

This wasn't going to be quick or easy but it was a start. She and Kasie were headed home and though she still felt a mess, the anger had dissipated. She'd made some significant discoveries and she'd managed to break her pattern, even if she had to physically remove herself to do it.

But when she didn't see his car in the drive as they approached the house, she began to feel the panic rising up again. "He's not back?" But just then, in the nick of time, he drove down the street behind them. Seeing his two best girls bopping down the road had put a huge smile on his face. She managed a relieved smile back at him and, as usual, Kasie lost her mind seeing Daddy. As he got out of the car he said, "Well, look at you two! Out for a little stroll? It got warm, huh?"

"It did!" she said and threw her arms around his neck.

He held her close. Perhaps she hugged him a little too tight or a little too long, because he pulled away from her. Holding her at arm's length, he eyed her intently and said, "Hey. What's going on? Are you OK?"

"Yeah, I'm fine. Just glad you're home."

He looked at her sideways, unconvinced. "Have

you been crying?"

"It's nothing... it's just... stupid," she waved him off and looked away but, in spite of herself, she started to cry harder. It had been a very long afternoon. She wanted to tell him everything, and yet she didn't want to say a word.

"C'mon! You're crying! What is it?"

"Nothing! It's... nothing."

"It's obviously something!"

"It's just..." and as she was about to let it all spill out, she said, "Oprah! I've been watching Oprah"

"Oh, Jesus," he said, laughing, "I don't even want to know." He put his arm around her shoulder and the three of them walked into the house together.

"Hey, something smells good in here!" he said, "Kasie! Did you cook dinner?"

"Yeah, she did! Cleaned the house and did the laundry, too."

"Good girl, Kasie!"

"Yeah, those doggie daycare classes are worth every dime."

"So... I guess your Red Sox shirt is in the dryer?" he said.

She smiled, rolled her eyes, and shook her head. "Kasie, I think you better help Daddy set the table."

She wanted to tell him, and she would. Just not now. It was enough that she had been able to make a different choice. All she wanted right now was to have a nice dinner and enjoy the evening, and so

they did. This was going to be a very long process of undoing and relearning. She didn't know it that day but was going to take years. *Years.* And just when she thinks she's done all the work, she will discover that more work is needed, but she had started the process. And starting the process, she would also learn, had been the biggest step, and the hardest part, by far.

CHAPTER SEVEN
Spiral

She sat on the front stoop sobbing, unable to move. Hunched over like a heaving dog, hugging her knees and clutching a wad of disintegrating tissues. About fifteen minutes ago she'd managed to get herself off the couch where she'd been parked, withered and absent, for the fourth consecutive day and had made it through the front door. She tried to stay upright but like cool syrup she slid down the side of the wrought iron railing and onto the steps. Now all she had to do was get up and walk to the mailbox and back and maybe she'd feel better. Just a little bit better. But she couldn't do it. It was too much. She hoisted her ladened head from her knees and stared out the driveway to the mailbox about seven hundred feet away. There it sat, atop a white painted cedar post, surrounded by daisies bobbing their empty heads in the breeze. It may

as well have been ten miles – or fifteen feet. It didn't matter, it was too far to conceive. "Please just help me get up," she pleaded to a somber sky. The help didn't come and so there she sat crying, searching for the energy or the wherewithal to make herself move. Fifteen minutes, twenty minutes, twenty-five... the time oozed by, thick and distorted.

This had happened before, more than once, and had overtaken her at varying speeds and intensity. Sometimes it leached in with the change of seasons, like the osmotic transfer of gas from an inflatable pool toy left floating past the end of summer, sad and wilted, the air having seeped out in infinitesimal degrees. Sometimes she could fight it off, catch it before things got too grim. Not this time. This wasn't a seeping pinprick – this was a gaping scissor hole in a giant helium balloon. She had spiraled down. Hot wind escaping her, she staggered and swayed until she was in a deflated heap, slack and flaccid on the sofa.

It had happened a few years ago, although not this bad, and a chirpy classmate had suggested she just snap out of it.

"Just... 'snap out of it'?" she repeated.

"Yeah! Snap out of it!"

"It's not that simple."

"Sure, it is! Like the song says, 'Put on a happy face'!"

"Are you kidding me right now?"

"No, I'm not *kidding*. It's mind over matter. Just distract yourself by doing something that makes you happy. Stop thinking about it. You know, Snap out of it!"

She looked at the woman through a haze of disbelief, and deadpanned, "Just snap out of it. Gee. Why didn't I think of that?"

Another friend enquired why she didn't just "ask for help when things got bad?"

"Because you can't."

"What do you mean you *can't*? You just pick up the phone and ask for help. It takes two seconds!"

"I mean you can't; not when you're in the depths of it. That's the insidiousness of it. When you need help the most is when you're least able to ask for it."

"That doesn't make any sense. If you're sick, you call the doctor. If your car breaks down, you get it to a mechanic. If you have a drinking problem, you go to AA. When you need help, you ask for help!"

"That's like telling someone who is trapped under a piano to walk over to the phone and call the movers. You simply can't."

"Of course, you can! You're not actually trapped under a piano and you're not paralyzed, are you?"

"Well, no, obviously it's an analogy. But in a way you are... paralyzed, I mean."

"Oh, come on, I think you're being a little dramatic."

"And I think you're being dismissive and over-simplifying it."

"Because it's pretty simple. You just ask for help."

"I don't think there's anything I can say to help you to understand how it feels. I just don't know how to explain it if you've never experienced it."

"Well, I think if someone needs help, they should just ask for it."

She sighed and said to her disbelieving friend, "Maybe the name says it all. It's a good name for how you feel. 'Depression'. There's the word depression like a hole in the ground and you definitely feel like you're stuck down in a hole. And there's depression in the sense that something is pressing down on you. It absolutely feels like there is a physical weight on you holding you down. It's an explicably heavy. It's heavy in your mind. It's heavy in your lungs. It's heavy in your body. Sometimes, when it's really bad, it's nearly impossible to move."

"*Nearly* impossible... but not impossible. You could still get to the phone."

OK... Whatever...

But that was then and now she was alone. No nonbelievers to convert nor pep talks to deflect.

For her, medication had worked to a degree and only for a while. The struggle to find the right prescription and dosage, combined with the ever-

growing list of side-effects, had proven too much for her. She also swore she could feel the drugs in her system and they made her feel toxic, for lack of a better term, and she couldn't stand it. So, under her doctor's guidance she'd titrated off her meds.

She'd discovered that, for her, the best way to loosen the grip of despair and keep it at bay was intense, intentional, physical exercise. As she slowly increased the time she spent walking, then running, her doctor kept close tabs on her progress. It had worked. It was her magic pill and, like any prescription, she had to take it without fail or face a relapse. She'd found that the more/less she exercised, the more/less she wanted to, and the better/worse she felt. It was self-perpetuating in both directions, and over the past couple of months she had gotten lazy. Her laziness turned into malaise, the malaise had become despondence and despondence had gotten her here. Sitting languid and bleak between a spitting gray sky and the gravel drive.

It was late September in the north. The days were growing shorter and the cold would soon set in; winter would not be long behind. The hibernal season was always a struggle and it was harder to manage her mood. The window of opportunity was closing. If she didn't get ahead of it straightaway there'd be no escaping without medical intervention. She had to move her body so her

mind could follow, it was the only way out and would happen right now or not at all.

She had to dig down really deep, excavate some minuscule untapped reserve, the survival instinct maybe, and use it to push back with everything she had left.

'OK. On the count of one... two... three." She took a deep breath in and with the exhale, slowly rolled forward off the step onto her hands and knees into the small dusty stones. She looked out to the end of the drive, toward the empty road and the stand of pines beyond, then hooked her eyes onto the mailbox. *Just get there. Crawl if you have to – but go.* She crept a few feet forward on all fours, the sharp pebbles jabbing into her knees and palms "*I think you're being a little dramatic...*" she rolled her eyes. Sitting back on her heels, she pushed with her hands and came up into a four-point squat. She sat there for a minute *keep moving, keep moving* then, fingers splayed on the ground, she stuck her fanny in the air, grabbed hold of her thighs one at a time and hauled herself up. Arms crossed over her stomach and chest, stooped and shivering, she hugged herself. *move* Taking tiny steps, increments of half a footlength, she shuffled forward; right, left, pause, right, left, pause. "God it's so hard." *keep going, keep going...*

Over the past couple of years, she'd become

an athlete. A trail runner, she ran twenty-five or thirty miles a week, up and down ski slopes in the summertime, yet right now she could barely move. There was nothing physically wrong with her but depression is an autocrat and she'd fallen under its totalitarian rule. It forbade her from moving with her normal grace and ease and instead had her shackled and chained, but she kept going.

"You should die from this," she breathed aloud, "if there was a true, proportionate cause and effect, feeling this bad should, in all fairness, kill a person." *keep going, keep going* "But it doesn't. It squeezes the life out of you but doesn't actually kill you."

She was halfway there, halfway to the mailbox. She didn't pick up her feet, just sort of slid them along, rocking back and forth like a sickly penguin, leaving drag marks behind her. It hurt to move, it hurt to breathe.

"Please help me," she turned her face upward and beseeched the misting sky, "please give me a sign. I need something, *anything*, so I know this will all be worth it. If you do, I promise I'll believe it and I won't give up. I promise I'll keep going." *right, left, right, left* She was closing in on the letterbox, tears flowing. Her body ached. No random flash of lightning or clap of thunder came, just the sound of the breeze in the pines and her feet scratching in the pebbles. When she was

about ten feet away, she extended an arm *right, left, right, left, almost there... reaching... reaching...* fingertips touching the cold damp metal. "I did it," she feebly cried, "maybe there's something in the mail today... Maybe that will be my sign." She opened the box and peered in. Nothing. Just a flyer from the market with its weekly specials. Not even *real* mail, just more junk.

But with or without a sign, she'd made it. *Oh... God...* she turned around and, clamping her Kleenex and the stupid flyer to her chest, stared blankly back down the driveway to the house. "Oh, no. Oh, God, no." *now I have to do it again.* It was so *far*. "Just get it over with and then you can be done." She breathed in and started back *right, left, right, left, right, left* she resumed her melancholy rhythm.

Her gaze was fixed, yet something moving high in a tree caught her periphery... a bird; a crow or a raven maybe. She paused and looked up (if only to give in to the urge to stop moving) and there he was, flapping his wings just a bit, arranging himself on his perch. The huge chocolate covered body and glorious white crown were unmistakable, even at this distance. Bald Eagles were common up here but this was no ordinary creature and she knew it. Strength, pride, power – yes, this was her eagle and she understood the message he brought. She sniffled, dragged her damp sleeve across her nose and cheek, and nodded. "OK. OK.

Thank you. This is good. Thank you," she whispered, "I can do this." She regained momentum *right, left, right, left* "I'm a runner, I'm an athlete, I eat hills for breakfast, Goddammit." *Keep going* Hand outstretched, she grabbed hold of the railing and climbed the three steps to the house. She made it back, albeit barely, and let herself inside.

She got out of her wet clothes and wrapped herself up in her accomplishment and a fluffy robe. They comforted her and it felt really good. She would get something to eat, she thought, take a hot shower, go to bed and watch TV. She still felt like hell but she'd done it. She would get some sleep tonight. And first thing tomorrow morning, she told herself, she would go to the mailbox again... and maybe just a little bit farther.

CHAPTER EIGHT
Skinny Jeans

Today I threw out my skinny jeans. Not because they didn't fit... they don't always, sometimes for a year or more, but they fit right now. I didn't do it because they were old or ugly. I mean they were, I've had them for over fifteen years. I did it because I didn't own them, they owned me. I did it because they didn't have to fit me, I had to fit them. I was sick and tired of hoping "they" would fit. I'm totally over allowing myself to be told if I'm the right size, or if I'm looking good, or whether or not I should walk with confidence... by a PAIR of PANTS! So, I let them go. And then I chucked 'em into the trash. I'm pretty sure I can take care of myself and stay at a heathy weight without the help of Inspector Levi.

CHAPTER NINE
Eighteen Dollars

It seemed an excessive amount at the time. And that was on top of the one hundred twenty-five dollars they'd already laid out. Fifty dollars for two nights in a "cabin tent" and seventy-five for the zip lining tour. Each! And that wasn't including food or gas! It was a lot of money to them. They had gone to school together in the alternative health care field and though their small private practices were, for the most part, doing well enough to cover expenses and make ends meet there was scarcely anything left over. But as the saying goes: "Nothing changes if nothing changes". If they wanted to live a different kind of life, they first had to believe that they could.

For months they'd talked about finally taking a trip somewhere. And when they said a "trip", they meant a road trip across at least one state line to do something new and different... for now,

anyway. It was a well calculated stepping-stone. Something that would consciously stretch them just beyond their current monetary reach but not so far as to cause anxiety or put them into debt; that exhilarating sweet spot right in the middle. It was part of their newfound practice of the "Law of Attraction". Instead of lamenting their current financial situation and lack of travel budget, they shifted focus to the possibilities and acted "as if". "As if" travel was already part of their current lifestyle and something they could well afford. They intentionally chose something nearby that was so exciting and adventurous just the thought of it was thrilling – a zip lining canopy tour! Just saying the words made them feel more exotic!

And now, on the phone with one another and about to book the trip, they were taking the leap from talking and dreaming to planning and doing.

"From your house to my house then to the zip lining place is roughly one hundred and fifty miles so about three hundred miles round-trip. I get twenty-five miles a gallon, give or take, and it's mostly highway so probably more. You?" She was a planner, that one, and when she was excited could talk the paint off a Buick.

"Yep! About the same."

"OK, cool. Three hundred divided by twenty-five is twelve, so we need about twelve gallons of gas which is about three eighty-five a gallon. Jeez, that's so ridiculous... the taxes in this state!"

"I know, right? Anyway, keeping it positive..."

"RIGHT! Positive! Let's round up to four bucks a gallon since we live in a place of abundance! Twelve times four is forty-eight, so let's say fifty divided by two. Twenty-five bucks each for gas. Have you got twenty-five bucks for gas to make this happen?"

"Um, yeah, I do! I'd even go as far to say I got another fifteen bucks for lunch!"

It was settled. They would stop for lunch on the road at a super casual Mexican restaurant they'd found online. They'd even spring for a soda or lemonade with their meal, not just water, which was free and much better for you, but this was a celebration! They would also be splurging on individual cabin tents...

...Five years earlier:
12:27 am:
"Pssst. You awake? Pssst."
"Huh?"
"I am so sorry to wake you but..."
"What? What's wrong?"
"You're snoring."
"Oh shit, I am? I'm sorry."
"It's OK, go back to sleep. Sorry to wake you."

1:43 am:
"Pssst. Hey."
"What?"
"You're snoring again."
"Am I?"

"Yeah, sorry. I don't mean to wake you but I really can't sleep"

"No, no, it's fine. I'll stop."

"'K. Night"

"G'night"

2:21 am

"Hey! Wake up!"

"Oh man! Again?"

"Yeah. Again. I hate to keep waking you but it's pretty loud."

"I don't think I usually snore. The air in here must be dry."

"Probably. Maybe if you prop yourself up on another pillow or something?"

"Yeah, OK."

3:12 am:

"OH, MY FRICKIN GOD!"

"SERIOUSLY? I really don't think I'm snoring!"

"Trust me! You're snoring!"

"Well I'm not doing it on purpose!"

"It's three o'clock in the morning and I haven't slept more than twenty minutes!"

"It's not like I'm getting a ton of sleep over here either!"

"Oh, believe me, you're sleeping!"

"Doesn't feel like it."

It was a long Goddamned night. The decision made the next morning was quick, unanimous and final, and it was never to be discussed again.

Anyway, with the cabin tents (plural) came Hibachi grills, so they would bring an ice chest, swing by the grocery store on the way to the campground, buy sandwich stuff for lunches, and hamburgers and hotdogs for dinners on the grill. The outdoor adventure place told them there was a tiny mom and pop diner right down the street where they could get a big breakfast for under five dollars apiece. Sweet! When they weren't zip lining, they could go swimming in the river across the street for free or just chill out on the deck, reading.

Cabin Tent	*$50-*
Zip Line	*$75-*
Gas Money	*$25-*
Lunch on the road	*$15-*
Breakfast	*$10-*
Groceries	*$20-*
Total	*$195.00*

The entire three-day trip would come to about two hundred dollars each. Sixty-five dollars a day for a vacation that included food, lodging, transportation, and entertainment? "I don't care who you are, that's a good deal!" Coming up with the money would be a challenge, but sitting around waiting for the perfect time to go had gotten them, literally, nowhere. After one last look at the total cost, "Screw it," they said, "we're going!" It was time to pull the trigger.

"We're booking this right now!"
"I'm already on the website!"

They were on the phone with one another from their respective homes, booking the trip simultaneously, each putting their share on their own credit card. They had done their research, so they knew they would go on a weekday, taking advantage of the fifteen-dollar mid-week discount. The exact same zip tour was fifteen dollars more on the weekends and far more crowded. With a couple months advanced notice, and neither one of them having taken so much as a single vacation or sick day in the past year or so, they would take the time off from work. They could easily move some clients around without losing any income, and even book a few extras in the upcoming weeks, so "doing it any other way would be stupid and wasteful!"

"It's like paying full price for a movie after 6 pm when you could see the exact same thing at a matinee price! I mean, who does that?"
"Exactly! It's cuckoo!"

Anyway, they would charge one hundred twenty-five dollars for zip lining and lodging online, then use money they'd squirrel away to pay off the balance before the trip. The plan was to scrimp and save and stash twenty-five bucks a week, pay off the credit cards in two payments over the next two months and use cash to pay for

everything else.

This served two purposes;

1) They knew that charging small amounts on their credit cards, then paying them off in full, would help to raise their credit score which, thanks to student loans, needed all the help they could get.

2) By the time the trip came it would already be paid off. They would go away knowing no bills were coming. It would almost feel like a free trip!

It would be tight but they'd have enough to make it happen! It could not possibly be any more exciting!

"OK, I'm clicking on the zip line tour page."
"Got it."
"We're doing the zip on Tuesday the seventeenth at nine-thirty, right?"
"Yes, and done! One zip line tour added to basket!"
"Oh, my God! OK, now the cabin tent! We're driving up on Monday and staying two nights, right?"
"That is correct."
"Adding my cabin tent to the basket!"
"You ready to check out?"
"Ready and... done! Oh shit. OK, adding name and address. Ugh, freaking details!"
"Now credit card information."
"I'm putting it in right now!"

"That sounds DIRTY!"

"Pervert. Real mature, too."

"I know you are but what am I?"

"K, I'm hitting enter! One, two, three!"

"Done!"

"Wait. 'Would you like to add trip insurance?' for EIGHTEEN DOLLARS?!?"

"WHAT?"

"Yeah! Look at that! Eleven-fifty for zip lining and three-twenty-five for each night in the cabin tent!"

"What the feck?"

"I know! Eighteen dollars? Do we want to do that?"

"I don't know... we probably should but... eighteen dollars?"

"I know, right? That seems like a lot. It's almost another night in a cabin tent!"

"But, OK, what if something happens and we can't go? I don't want to lose a hundred twenty-five dollars."

"But if everything goes fine, which it probably will, then we're just pissin' away eighteen bucks."

"Right?"

"And with the Law of Attraction, are we sending bad energy if we buy trip insurance because it means we think something will go wrong?"

"OR are we sending bad energy if we DON'T buy it because we feel we can't afford it? Doesn't that mean we're focusing on the 'lack of money'?"

"How the hell are we supposed to know that?"

"CRAP! Are we sending bad energy NOW because we so freaked out?"

"Probably!"

"OK, OK, what if we spend the money, buy the trip insurance not because we fear that something will go wrong, we buy it because it's the wise thing to do and we're able to. Ya think?"

"Yes, focus on the 'Abundance'. AND if we DON'T buy it because we feel we can't afford it, then we'll be afraid something *will* go wrong. Then we're focusing on the fear, so something is BOUND to go wrong."

"YES! And... if we spend the eighteen dollars then we won't CARE if something goes wrong because we're covered, right?"

"I'm checking the box for the insurance. Jeez, I hope our sessions didn't time the fuck out."

"Clicking next and... nope, we're good!"

"Checking all our info and... it's processing... DONE!"

"Holy moly! WE'RE GOING ZIP LINING!"

"We're going on VACATION!"

"You can drive to my house and be here at, say, ten o'clock, leave your car here and I'll drive the rest of the way, sound like a plan?"

"Um, yeah... it's still two months away but OK... sounds like a plan."

"Mock me if you will but now you have two whole months to plan on being here on time."

"Thanks, MOM. Maybe I should pack and put my stuff in the car right now, you know, to be

safe?"

"I just want to make sure you have enough time so you're not rushed and I'm not stressed. Although if you want to do it now I, for one, will feel much better. Maybe I should come down there and pick you up now and you can just stay here the next two months."

♥ ♥ ♥ ♥

8:30 am May 16th, packed and ready to go, her cell phone rang.

"Hi! Are you out the door? I, of course, have been ready since about 6 am, and when I say 6 am, I mean 6 am day before yesterday, but no pressure!"

"Hi."

"Uh oh. What's wrong?"

"Please don't be mad."

"Mad? Why wou..." she let out a huge sigh as her shoulders fell, "you're gonna be late, right?"

"Please don't be mad. I'm so, so, sorry."

"How long before you leave?"

"That's the thing. I'm not leaving."

"Huh? What do you mean?"

"I'm sick."

"Aw, *no*. What's the matter?"

"I was hoping I'd feel better and I could still go. That's why I didn't say anything."

"You poor thing!"

"I really want to go. We took the time off and everything."

"I know. But, if you're sick... what is it?"

"Stomach bug. I'm so sorry."

"It's OK. You don't want to force yourself to go and feel like crap the whole time, right? Besides, it's no fun for anyone if you're flying through the air ralphing all over the place!"

"Aw, jeez."

"Too soon?"

"Li'l bit."

"Sorry. Bad joke. I should call them A-SAP and tell them we're not coming."

"I guess. Good thing we bought the trip insurance."

"The trip insurance! Yes! We can just reschedule! Unless you just want to cancel."

"No, no! I definitely want to reschedule! How 'bout two weeks from today?

"Let me check my shhhhedule... yes! That works! I'll call them now."

"If you don't mind. I'm so sorry."

"Stop apologizing! It's fine. As you so aptly pointed out, we threw down beaucoups bucks for insurance, like a couple a Rockefellers."

"We live like rock stars."

"We'll probably trash the place once we get there."

"I think it's likely."

"OR, we may just go to bed at nine o'clock and read. You don't know *what* the hell we'll do!"

"We do what we want!"

"Yeah we do! And right now, we want to call

and let them know we're not coming. I'll call you right back. In the meantime, get your narrow ass into bed and take care of yourself. You have the day off!"

"Don't tell me to go to bed! I do what I want!"

"You're such a hellion. Now go to bed."

They rescheduled for the morning of the seventh and departed without a hitch. Sitting outdoors at a lime green picnic table on a glorious June day, they chowed down on burritos, taquitos, chips and guac, washed it all down with gargantuan icy soft drinks and, grinning ear to ear, savored every last bit of it. They stopped and shopped at a nearby grocery, loading up on food and all the fixin's, coming in at an impressive three dollars and twenty-four cents under budget. Arriving at the campground about an hour later, they checked in, chucked all their crap from the car into one of the giant wagons provided by the campground and hauled it up the steep, wide, dirt path to their cabin tents, laughing, grunting and swearing like sailors the entire way. The BBQ was splendid and they ate like lumberjacks. They were "away" and having the time of their lives.

Before the sun set, they made their way over to the coin-op showers, one of them thrilled that they had showers at all, the other entirely freaked out by any type of communal bathing situation.

The bathhouse was a utilitarian wood structure built on a poured concrete slab, typical of nearly every campground in America, its timber framed skeleton fully visible from the inside. Halved by gender, the women's side was divided into three sections; four toilet stalls to the left, three shower stalls to the right, two mirrored sinks in the center.

"'WOW! The overhead fluorescent lighting in here makes me look and feel like a million bucks! …said no woman ever."

The shower cubbies were an opulent three-by-seven-foot rectangular plywood box painted, like the rest of the building, in a fetching shade of chocolate poop brown. Half that space was a metal shower stall outfitted with a plastic curtain the color of ageing buttermilk. Too small, it allowed water to escape and puddle on the cement floor beyond, aka the private "dressing" area. With the partitioning walls presumably too thin to screw in a clothes hook, a bilateral duo of wood plank benches were provided as a place to put your things. At a luxurious six inches deep apiece, situating your towel, clean clothes and personal items in such a way so as gravity wouldn't heave them onto the sopping wet floors became a precarious, anxiety ridden, balancing act. Dropping your clean unmentionables onto that floor was a horrific event to be avoided at all costs, allowing your worn clothes to suffer the same fate was

only slightly less repugnant. An expansive two-and-a-quarter foot gap between the bottom of the enclosure and the floor left inhabitants exposed from just above the knees down (or from the thighs down if vertically challenged). Once undressed, if anything did, God forbid, drop to the floor one must carefully bend at the waist, rather than the knees, to retrieve it but refrain from engaging in a full yogic forward fold at the risk of exposing your naked, upside down, upper half to unsuspecting onlookers. Needless to say, flip flops providing a hermetic barrier between your feet and the perpetually damp floor were an absolute non-negotiable. The entire building was of dubious cleanliness and had been very accurately, if not somewhat generously, described as "rustic". But, hey, they had flush toilets and for seventy-five cents in quarters, a ten-minute piping hot shower in the middle of the woods.

An adventure unto itself, the door to access the building was armed with a spring loaded, self-closing, coil hinge so thick and mighty that opening it required grabbing hold of the knob while firmly planting both feet, clutching one's abdominals, and leaning back with nearly all your weight. Grunting "Oh... my... GOD!" through your teeth seemed to help. Once open, if not expeditious about threading your entire body through the narrow crack in the door, one could easily imagine lopping off an errant limb as it slammed be-

hind you with an aggressive THWACK!

"Holy shit!"

"Yeah, I think it's to keep animals out."

"Animals? A fucking SASS-quatch couldn't get through that damn thing!"

They stopped and faced each other and said in unison: "Oh, yeah... there's SQAATCH in these woods."

"It never gets old."

"That shit's funny."

"By the way, I am SO doing that later when it's dark out, with a flashlight shining up under my chin."

"I'd be disappointed if you didn't."

"Oh wait... the weird green flood light is the bigfoot video... the flashlight under the chin is Blair Witch."

"SHUT UP, SHUT UP, SHUT UP! Do NOT mention that movie to me when we are staying here in the fucking WOODS!"

"Oops. Sorry."

"You're not sorry. I had to drive all the way home that night after watching that stupid fucking movie!"

"Oh, here we go."

"Over an HOUR home!"

"I know."

"In the PITCH BLACK."

"I remember."

"ALONE!"

"I'm sorry."

"Through the WOODS!"

"Well how the hell was I supposed to know you'd get so freaking scared, Miss Queen of the Fucking Horror Movies? You watch those stupid gory slasher movies ALL the TIME!"

"THAT is DIFFERENT!"

"Whatever. I don't think anything is gonna get through that door, Squaaatch, witch, or otherwise, so I'm pretty sure we're safe in here."

"Not from bacteria... or spiders, apparently."

"It's not that bad."

"I beg to differ."

"You need to dig down and channel your inner Honey Badger."

"Honey Badger don't care."

"Honey Badger don't give a shit."

"Speaking of shit... I hope Honey Badger don't have to go pee in the middle of the night. I do NOT want to come back down here under a cloak of darkness."

"No kidding. We seriously need to stop all intake of fluids by 2 pm tomorrow."

The next morning, after a hefty breakfast, they made their way over to the designated meeting area to get suited up with harnesses and helmets. After being briefed on safety and protocol, they headed over to the training and practice area with the rest of their troop. They were part of a group of eight first-time zip liners; two buddies from

Boston, a father and pre-teen son, and a set of adorably googly-eyed honeymooners from California. Two impossibly athletic and extremely patient twenty-something guides completed the group. It was scary and exhilarating taking their first flights on a training zip about ten feet off the ground, but now they were heading up into the trees and ready for the real thing!

They all hopped aboard one of three very bad-ass four-wheel drive buggies that roared up on cue to take them up the mountain. With big knobby tires, no doors, and heavy-duty roll bars, they felt like something straight out of Indiana Jones and easily motored up the muddy dirt road to the zip lines, hidden high in the canopy of the pines. Their excited shrieks, chatter and laughter and the growl of the motor drowned out the first rumbles of thunder.

The slope of the first zip lining hill was so steep that the launch platform was at ground level, but only fifteen feet out on the line the forest floor dropped away, leaving the zippers airborne!

The first guide clipped onto the line and, without a word, flew through the air like Tinkerbell landing soundlessly on the platform below. She gave a high thumbs up to her partner, who said, "OK! Who's going to be first?" Everyone looked around, avoiding eye contact with the guide. The newlywed bride whispered, "Not me," as she

examined the tops of her boots.

"Go on, son!" the dad yelled out.

The boy nodded and said, "Sure! I'll go!"

"All right, pal, woo HOO! You're up!" The guide clapped her hands and the whole group joined in and cheered their support. She hooked him onto the zip line, double checked his fittings and said, "OK, just like in practice, nice and easy."

Without a moment's hesitation, the boy stepped away and off he went! As he zoomed through the air, the whine of the trolley wheels speeding down the cable, he let out a comical, dissonant Tarzan yell which got a big laugh and a round of applause from the group. The dad shook his head, grinning and said, "Yep, that's my kid! No fear. Gets it from his mother."

One of the girls leaned into the other and said, "Look. So easy even a child can do it."

"It's handy they have that giant tree to stop us if the brakes don't work," said the other.

"That was AWESOME!" shouted the youngster as he landed triumphantly.

With varying degrees of trepidation, the rest of them followed. All agreed it was thrilling and fabulous as they high-fived and clapped one another on the back, their enthusiasm and a thick umbrella of trees obscuring the rapidly darkening skies.

Maiden voyages under their belts, they anx-

iously lined up for their second trip through the canopy and, once again, all landed safely, if not gracefully. Just as the second guide hooked onto the zip line to make her way to the rest of the group, she picked up her two-way radio and said, "Go ahead." Although they couldn't quite make out what the guy on the other end was saying, she responded with, "Roger that. We'll have 'em ready," hooked the radio back onto her belt and hopped into the air, flying toward them.

When she landed on the platform where they all stood, she looked at the other guide and nodded slightly. Then she clapped her gloved hands together and said, "OK! I'm going to need everyone's attention. First of all, there's absolutely nothing to worry about, I promise, but we have to make an emergency exit from the zip lines. We're going to rappel down from this platform and the buggies will take us back down to base. As I said, everything is fine but we have a line of severe thunderstorms moving in pretty quickly and, as you can imagine, being harnessed to a big metal wire high up in the trees? Well, maybe not the best place to be." They all laughed nervously and, looking up, saw that the treetops were bending and bowing in the wind. "As I said, the storm came together and is moving in rather quickly, so we have about fifteen, twenty minutes to get everyone down to camp which, don't worry, is plenty of time but we've got to move."

"On belay!" the guide called out as, one by one, the zippers leaned back into the harness, gliding down to the ground like spiders on a web. The closer it got to her turn, the more frightened she became. Part of the reason she'd come on this trip was to confront her intense fear of heights and, so far, she'd done better than expected... until now. As easy as the others had made it look, leaning backward into "nothing" fifty feet in the air just didn't seem like something she wanted, or would be able, to do. The thunder was audible now and fat drops of rain were making it through to the forest floor. Up on the platforms, the sway of the huge trunks in the wind was becoming more and more pronounced. She was squatting down on the platform, her back to the edge. "All you have to do is lean back. Just lean back." The seasoned crew were doing their best to cajole her into trusting them to lower her to safety, but as the urgency to get out of the trees and back to the safety of base camp increased, so did her fear.

"Is there going to be a jolt? Will I feel myself drop?"

"Not even a little. It's as smooth as silk, I promise."

"Did you guys feel a jolt when you leaned back?" she yelled down to the others, "I mean, sorry, not that I don't trust you," she said to the guide, "it's just... I guess I need a consensus."

"NO, not at ALL!"

"It's super smooth."

"You got this!" they said all said at once.

She started to lean back and "I CAN'T! I just can't do it! I'm sorry!" She was on the verge of tears.

"Oh, honey, you can do this! You're the bravest person I know!" her friend called up to her, "but if you want, I'd be happy to come back up there and give you a li'l shove."

It had the desired effect and made her laugh.

"I think you might have to," she said.

The guide looked her in the eyes and said to her softly, "I know you're afraid. I know this is really scary for you, I totally get that. I don't want to pressure you or make this any harder but there's a bad storm coming, we all need to get inside and we're running out of time. There's no other way down and we're not going to leave you here. Would you consider facing your fear and doing it for everyone else? So we can all go inside?"

The two women looked each other in the eyes. She said to the guide, "Wow. You're good. I'M COMING DOWN," she called to the others. She leaned back, tears streaming down her face, certain she was going to plunge to her death. And about five feet into her descent she said cheerfully, "OH! This isn't so bad!"

"Oh, my God, I'm gonna fuckin' kill her," said her friend.

"If you're quick about, it you can grab a stick

and whack me like a giant pinata."

Back down at base camp, the crew offered everyone in the group a full refund or a rescheduled tour the following morning, whichever they preferred.

"Normally," the guide said, "we don't run zip tours on Wednesdays, but we're adding one to the schedule just for you guys! Show of hands – who's coming back tomorrow morning?" Since they were staying over that night, the two women looked at each other, nodded and shot their hands up in the air. Looking around, they saw no other hands raised... only disappointed faces and heads shaking no. "OK, ladies! We'll see you back here at 9:15 tomorrow morning. The rest of you, come on over and we'll process your refunds. The lovely Erin and Josh are bringing out drinks and snacks, so help yourselves – and everyone, please, hang out here in the Gear Shed until the storm passes and we get an all clear."

The next morning was warm and cloudless and they enjoyed their private zip line tour. Because they'd completed their training the day before and two people moved through the course so much faster than a group, the guides had time to take them through the entire zip tour twice. All for the bargain basement price of eighteen dollars. Only a year ago, they would not have believed their luck, but now, they were certain it was so much more than that.

CHAPTER TEN
Grief

She smiled and kissed her sister on the cheek and they hugged each other goodbye in the front seat. "Thanks! That was fun!" She hopped out of the car, "see you soon!" and stood on the curb blithely waving as she watched her sister drive away, waiting until she was out of sight before turning to go inside and allowing her face to fall. She walked casually at first, her steps getting quicker the closer she got to her door, her façade crumbling onto the sidewalk at her feet. The housekey was out and ready and she tried to steady her hand as it skidded around the keyhole, finally connecting with the slot and slipping in. She shoved the door open and, with her back, slammed it closed behind her, knees buckling, sliding down to the floor. Like a thousand bats gushing out of the mouth of a cave at nightfall, she cried out in a squall of anguish she could no longer

contain.

The day she moved into her new apartment, she laid in a ball in the middle of the living room floor and wept. She'd found an adorable little cottage apartment and, under normal circumstances, should have been happy – but the only reason she was there was because life as she'd known it had come to an end.

There she would lie, sometimes for hours but usually all day. The grief was an infected wound that needed to be leeched daily – for if held inside too long, she feared it would kill her. Until she needed to use the bathroom, she didn't bother trying to get up. She didn't want to. Mentally disappearing into a deep mourning was her deliverance; escaping into the salvation of a self-induced twilight state of consciousness.

Lying on the floor like this, curtains drawn, seemed the most natural place to be; all alone and in complete surrender. It was the only time when the demands placed upon her were equal to what she was capable of giving – absolutely nothing. Between bouts of hysteria, she lay there quietly breathing in and out, waiting for the next wave to hit. She had an angel in heaven looking down on her now so she'd wait for him to come. Sometimes she'd catch him whispering into her ear in that realm between wake and sleep. The

remainder of her time was torture. The excruciating walls of pain, the quiet in between, the feeling of being physically torn in two. Grief was the nefarious, hateful twin of the birthing process. But in the end, she was left with nothing but an execrable gaping void.

The day he was taken, the day it was over, the doctors had recorded the time of death, the clergyman had prayed to God to "welcome the departed into His Kingdom", the staff had offered their condolences, told her the men from the mortuary had arrived and would be taking care of things and would be in touch. She was free to go. *Go where?* She took her purse, clutched her keys and walked the long hallway toward the exit and parking lot. She muttered inaudibly and to no one in particular as she passed the nurses' station, "What am I supposed to do? Just... go home? Just leave? I'm not sure what I'm supposed to do." She was untethered and confused. She no longer had any idea of her place in the Universe. Who was she now? *No one.* What was she now? *Nothing. Alone.* Her role had changed, her identifying title stripped... poof... just like that.

She remembered walking out to her car – afterward – in a sort of disembodied dream state. It seemed as though someone ought to be putting their arm lightly around her shoulder and guiding her, gently taking the car keys from her hand, helping her home, but there was no one. Her fam-

ily wasn't there, they were on their way from out of state. The others who had been holding vigil with her had gone their separate ways. She left the building and walked out into the warm, cloudless afternoon.

The colors outside seemed oddly and offensively vibrant and saturated. Like someone had messed with the knobs on an old TV set and increased the intensity. The sky was too blue, the leaves too green, the sun too bright and the edges of objects were in soft focus. She had trouble understanding why people were sitting in their cars driving along, carrying on with their lives as though nothing had happened. They were just going about their business... *what the hell was wrong with them*? She couldn't reconcile it in her head.

She moved in slow motion and could hear Karen Carpenter sweetly singing a disjointed loop of lyrics in her head: "*Why do the birds keep on singing? Why does the sun shine above? Don't they know it's the end of the world? And da da da da da da my love...*" She felt horribly conspicuous yet translucent, unsure if she was occupying physical space. She got into her car and turned over the engine *I shouldn't be driving*. Backed up, headed to the exit of the parking lot and stopped the car. She'd lived here for sixteen years and it was only five or so miles home; a straight shot most of the way then two small turns, roads she'd driven literally thousands

of times but she couldn't get her bearings. She sat there, trying to figure out where she was and how to get to her house. *I shouldn't be driving.* She put her foot on the gas, made a left and headed home.

Once inside, the abandoned, haunted space that only this morning had been their home enveloped her and the heaviness pressed the wind out of her lungs. She could see his face, see him when he was leaving her, she could hear the rattle. It wasn't like in the movies. In real life it wasn't dreamlike and ethereal. Death was a bully, a murderer. It had wrapped its hand around his throat and choked the air out of him, then reached deep down inside and dragged the life out of him in its fist, right in front of her eyes. They don't show *that* in the movies.

She had told him it was OK to go. She had told him how perfect he was and how much she loved him and that it was OK if he had to go. It wasn't OK! She didn't mean it! They told her she should say that to help him pass, so she did. She knew they were right. She knew he needed to go so she did it to help him. She'd have done anything for him... even that.

She labored to breathe. Ramming her hand into her purse, she wildly grappled for the plastic vial. Latching onto it, dropping her bag to the floor, she slammed her palm onto the cap, pushed and turned in a single motion. Dumping a pile

of pills into her hand, some spilling to the floor, she pinched one and pushed it under her tongue. Panic rising, her whole body started to shake and she could feel the rage begin to surface. With no appearances left to keep, no one left to be strong for, she could finally unleash her wrath, rip the lid off of the frenzy, the madness, the tantrum she'd politely held inside all this time. The long-suppressed explosion was coming...

"It's not fair. It's not fair. This can't be real. Please tell me this isn't real!" She cranked her neck back and shrieked up at the popcorn ceiling, "WHHHHY? WHY DID YOU DO THIS? GOD! GOD? DO HEAR ME? DO YOU HEAR ME, GOD? WHY?" She screeched at the top of her lungs, "HOW COULD YOU DO THIS? I HATE YOU, I HATE YOU, YOU MOTHERFUCKER! I HATE YOU I HATE YOU I HATE YOU!"

She dropped to her knees on the hard tile floor and started screaming. Blood curdling screams until she thought her throat would bleed. "PLEASE! TAKE IT BACK! TAKE IT BACK! PLEASE!" She was panting. She could feel her throat closing, beginning to hyperventilate. *Breathe through your nose breathe through your nose.*

"Please take it back, God, PLEASE! I want him back I... I want him back I want him back, PLEASE! Please give him back to me, please. I'll do anything, anything. Please... it hurts, oh God, it hurts.

I can't stand it, please make it stop, please... please... just take me, too... please... please... please..." she whimpered.

The fight had gone out of her but the emotional torment remained, and without the guise and shelter of anger, it was crushing. She got up and went to her bedroom, drawing the curtains closed. She felt so weak and needed desperately to lie down. She needed sleep, she wanted to pass out. The Klonopin will help her sleep, she thought. *Sleep?* Who was she kidding? She didn't want to sleep. Sleeping meant waking, being faced with the incomprehensible prospect of getting up the next morning into a barren shattered world. That's when she saw it, remembered it... an out... She had thought of it weeks ago and many times since, filing it away for when she knew she'd need it. A way to stop the misery. A way to escape, erase it all and disappear from this horror show. *Just disappear*.

The thought of it was so seductive, so alluring. And morning? Tomorrow morning? That was just unfathomable. Impossible.

She went back into the kitchen and filled a tall glass with water. Returning to her room, she set it on the nightstand. She got out of her street clothes and put on her comfy clothes, climbed onto the bed and sat cross-legged, nesting a large Tupperware bowl filled with bottles of his pre-

scription pain medication. The agony she felt was already unbearable – but walking up tomorrow morning? No. No. That was going to be too much. The thought of waking up every morning from now on into some hellish Groundhog Day would be a relentless hell. She had a glimmer of memory from somewhere, maybe a past life? *Oblivion.* Oh, yes... she remembered oblivion. So sweet it was, and it called her like a siren onto the twisted rocky shore.

Then something else whispered to her, another memory, *"What is done cannot be undone."* "Where the hell do I know that from?" She sat there staring at the plastic amber tubes for a long while, trying to come up with one good reason not to down them all. Just one.

Forty-five minutes passed.

- It would be a disgrace to his memory.
- On the off-chance that he could see her right now, she didn't want him to feel responsible for her taking her own life.
- Although she was by no means a religious person, she had heard enough dogma that she couldn't know for sure if she would go to hell for killing herself, thereby voiding any possibility of seeing him in the afterlife, should an afterlife actually exist.
- Her family had been through enough.

She had come up with four.

She got up and carried the container to the bathroom, opened each bottle, woefully dumping their contents one by one, and flushed the pills down the toilet.

She couldn't bear to stay there without him, so she packed up and sold the house and moved nearer to her parents and sister to face the empty, ghoulish, shell of a life that, no doubt, lay ahead, allowing for the tiniest spark of possibility that it may not always be this unbearable.

Her family loved her and they were so worried about her. It had been a few months and they were glad to see she was doing better now. "Better", meaning she could manage to pull it together just long enough to put on a show for them, a performance to alleviate the pain of watching her suffer. Like Halloween, she would get dressed up in a costume of California casual, don her mask with the smile and a flicker of life in the eyes and allow herself to be seen for a couple of hours, every few days. Just long enough to convince her loved ones that she was OK and they needn't fret. It was her gift of love to them, not forcing them to watch the process. Having a lovely breakfast on the shady patio of a favorite restaurant with the big sister or parents she adored was a great comfort, and a small price to pay to buy herself the time to

completely collapse in between "sightings". Then she could peel away her butterfly wings and crawl back into her cool, dark cocoon where she didn't have to try to be anything but destroyed.

Pushing back the pain took an enormous amount of energy – energy she didn't have. Allowing her mind to naturally lapse, disappearing for days into a reparative state of inertia was her reprieve. The relief in being left to marinate in her sorrow was unquantifiable.

She wasn't going to be one of those "busy" mourners... the kind who wanted to be surrounded and uplifted by friends or to get right back to work, and she wouldn't channel her pain by becoming any sort of social activist. Her bereavement was to be the anti-social and very low functioning kind. There would be no picking herself up by the bootstraps. No one was going to find her inspirational or wonder "how does she do it?". No, she was choosing the grief. She knew there was no getting around an event this big, the loss would present itself one way or another so she'd rather dive into it and deal with it now, head on, instead of letting it come out sideways in a few years. When someone becomes severely physically injured, they must be still and allow their bodies time to rest and repair, it is socially understood and accepted. She would allow her deep emotional trauma the same consideration. That was the story she was telling herself and she was

sticking to it.

The truth was that she couldn't have fought it even if she'd wanted to – and she didn't want to. It was so much easier to let go and freefall into it. Let the pain take her, engulf her, wash over and through her – and in doing so, hopefully, eventually, she would work her way to the other side and find her way out. She would get dressed and go out for an hour or two, then she would come home and spend the rest of the time lying down alone with it in the dark, sometimes staring at mindless television for days... weeks... months.

If she let herself cry until the tears dried up then patiently waited for them to come again, soon (OK, maybe not soon, but someday) she'd be able to get out for two or three hours instead of one or two. She would go to therapy, sometimes spending the entire fifty minutes not saying a word, just crying in the presence of another human being. It was all she could do. But if she kept doing it, sooner or later (OK, later) the scale would begin to tip. She would let it take its course and someday, once again, the good times would outweigh the bad.

She smiled and kissed her sister on the cheek and they hugged each other goodbye in the front seat. "Thanks! That was fun!" She hopped out of the car, "See you soon!" and stood on the curb

blithely waving as she watched her sister drive away, waiting until she was out of sight before turning to go inside.

She walked casually up the path and stopped to admire the fountain she'd bought a little over a year ago, about six months after she'd moved in. It sat on the stone patio in the shade of a huge avocado tree. She'd happened upon it while shopping for plants in a small home improvement center and she was instantly enchanted. It was lovely and very simple, no spouting fish or frolicking cherubs, just three, tiered, basins in a natural concrete gray, standing about three and a half feet tall. The sound it made was so soft and pretty and it had been so long since something had made her smile. The housekey was out and ready. She slipped the key into the lock, pushed the door open and walked inside, a tender look crossing her face as she thought about the breakfast she'd just had with her sister. "That was really nice..." she said to herself.

CHAPTER ELEVEN
A Blog is Born!

In a car, a boat, or plane
Our lives will never be the same.
Like our energy, we flow.
Where we dream is where we go!

Sitting at the computer, intention and fingers poised, she begins to type:

"I BECAME A SOLO WOMAN WORLD TRAVELER IN MY 50s!

Hi! I'm 'a woman of a certain age' and I'm about to take my first big trip abroad! I live in my hometown and I've been dreaming of traveling for as long as I can remember. Initially, that dream didn't exactly include going solo but, hey, things change. A girl can only wait so long be-

fore she takes matters into her own hands. Several years ago, I stopped waiting for things to happen and started making things happen. Now I'm done waiting for 'someday' to travel. My 'someday' is here, and I'm going! And so can you! I'll share with you everything I'm learning on this amazing adventure... from itinerary planning and cell phone use in other countries to the all-important shoe selection! I want to hear your experiences as well so we can all learn from each other! Are you ready? I sure am! Let the adventure begin..."

February 16, First Entry:
"FROM THE 'BUCKET LIST' TO THE 'TO DO LIST'; A PARADIGM SHIFT

A trip abroad! I mean, how hard can it be, right? You just make a list and start doing it:
1) Get a passport
2) Pick a destination
3) Pick date
4) Buy a plane ticket
5) Book a few hotel rooms

BAM! You're on the brink of becoming a world traveler!

So that's exactly what I did.

Once I cleared the biggest hurdle, which was making the decision to actually go, I needed a destination. But, OMG, WHERE? When you decide you're really going to do it, suddenly, the world gets really big... and really small... in equal proportions and at the exact same time! I mean, we can, literally, go anywhere a plane flies or a boat sails. ANYWHERE in the WORLD! Isn't that exciting? Think about it: if you could go anywhere in the world, where in the world would you go? G'head... take a minute and think about it... I'll wait.

OK, I'm a natural planner with an eye for detail, a strong sense of adventure and, admittedly, a lot to learn – but I AM learning. I've found the most charming little inns and B&Bs in the most unbelievably picturesque villages, a romantic Air-

bnb and a fabulous hotel, both on the waterfront, in two of the world's most exciting cities (more about them later!). I'm doing it all on a budget and I've found that there are deals to be had if you're willing to look! Do you want to see how I do? I'd love to share my experience with you! Please come along! I'm planning my dream trip – and you know what THAT means? If I can do it, so can you!

Thought for the day: *'MAKING A LIST TURNS A DREAM INTO A PLAN!'*"

February 23, Second Entry:
"A GRAND AND A GROUPON

With the popular online discount companies, traveling has become so much more approachable. I've used them many times for various outings, from sushi dinners to weekend getaways, and always had a great experience – so, when I planned my first big trip, what's the first thing I did? Log on to Groupon Getaways! Oh, be still my foolish heart! Those panoramic vistas! Those exotic destinations! Punta Cana! Dominican Republic! Italy! Costa Rica! Ireland! Many under $1000? Are you kidding me? Suddenly, the world is my oyster! OMG! $799 for a seven-day trip to the Azores? Including AIRFARE? I want to go to the Azores! Wait... where, exactly, ARE the Azores? I went straight to the usual suspects: Google Maps and Google Images. Ooooh, Portugal! Well... sort of.

OK, this is all too much for me! I've got to reel it in and focus!

So, if you're like me, and don't know your number one destination off the top of your head (when asked the question: 'Where do you want to go?', my answer is 'EVERYWHERE!') just ask yourself, where have you always wanted to go? What type of culture or cuisine calls to you? Are there customs, rituals, décor or clothing that has always spoken to you? Do you collect certain artifacts? Are you drawn to books or movies set in a cer-

tain time or place? Is it exploration of your familial heritage that beckons? Was there a poem or a painting you wanted to step into as a child? These are your breadcrumbs. Follow the trail – they're telling you something. Listen.

Thought for the day: *'WHEN THE TRAVELER IS READY, THE TRIP WILL APPEAR'.*"

March 3, Third Entry:
"I SEE LONDON, I SEE FRANCE

After dreaming of countless possibilities, combing over dozens of destinations and swooning over, literally, hundreds of Google Images to see what really spoke to me, I finally made my choice... I'm going to England! Once I really narrowed down the focus on where I wanted to go, I realized I've been dreaming of visiting England since I was a girl. I was swept away by movies based on the works of Jane Austen, by watching A Christmas Carol with Alastair Sim, and with Merle Oberon and Sir Laurence Olivier in Wuthering Heights (which, much to my horror, I recently discovered was filmed... are you ready? ...in Thousand Oaks, CA just outside of LA! That's right, in the 1931 film version of Emily Brontë's tale of ultimate jealousy and woe, our Cathy and Heathcliff were writhing in emotional pain, NOT on the misty moors of Yorkshire, but somewhere off the 101 near the Conejo Grade... NOOOO! OMG, I can't even talk about it!).

Regardless, England has everything I'm looking for; history, culture, castles... I mean, I don't know about you but THIS American girl wants to see castles, and plenty of 'em! London Bridge, Abbey Road, The Cotswolds, Downton Abbey filming sets, Nottingham, West End theaters, and, of course, the Moors (the REAL ones)! I'm already breathless and I haven't even left the ground!

Additionally, and on a very personal level, my dear Nana and, thusly, my beloved Mother, were of English descent. We grew up drinking tea with our Nana, and the women in my family have gone to afternoon tea everywhere from the grand rooms at the Four Seasons with its fine china and crisp white linen to charming, hidden, one room, village tea houses with their collections of antique mismatched cups. It's a family tradition that is near and dear to my heart. So, England it is! As a bonus, there is no real language barrier. After all, I know that 'jumper' means 'sweater', so I'm good, right? RIGHT!

After I made my choice, I was excitedly sharing my upcoming adventure with a friend and she said, 'Oh you're going to love it! And once you're over there you can travel around so easily. You can hop on a train in London and be in Paris in a couple of hours.' In fact, once I started to talk to people about my trip, I found a lot of their sentences began with 'Once you're over there...' all of them recommending that I see as much as is reasonable and stay as long as I'm able. Now, I knew about traveling by train in the UK and Europe, of course, but somehow when my friend said it, a seed was planted and the wheels started turning. I made a few Google searches and I soon began to feel like Macaulay Culkin in Home Alone. You know, when he awakens that first morning and begins the process of realization: 'I made my family dis-

appear.' But instead, I was thinking: 'I can go to Paris?'........... 'I can go to Paris'................. 'I CAN GO TO PARIS!' I figured out my dates, booked a ticket and, I'm happy to report, I will be taking the Eurostar from London to Paris!

My list for choosing Paris is short and to the point:
1) Ummmm, Hello? It's PARIS!
'Nuff said!

So where will you go on your dream trip? What do you know of England and Paris? Comment below! I SO want to hear your stories!

Thought for the day:
'A SHIP IN HARBOR IS SAFE – BUT THAT IS NOT WHAT SHIPS ARE BUILT FOR.'"
~ JOHN A. SHEDD ~

March 16, Fourth Entry:
"3 WEEKS, 2 COUNTRIES, 1 BAG, OH MY!

Two little words that strike fear into my heart: 'PACK LIGHT'. And I mean REALLY light. I'm only bringing one carry-on bag that converts to a back pack for three weeks of travel. As tempted as I am to throw in just one more pair of shoes (specifically, my super cute black riding boots that come just below the knee) there is one unavoidable fact that may just keep that from happening... I'm biking through the Cotswolds for a week, and everything I bring I have to carry with me on that bike! How's that for incentive to edit one's wardrobe? Every time I want to add something to the list, I ask myself: 'Do you really want to carry that?' Sometimes the answer is a very clear and resounding 'NO' and other times... hmmmm, not so much! Take those boots, for instance.

My vacation plans and activities are rather diverse, exponentially increasing the challenge. For the first portion of the trip I'll be biking in England, quite possibly in a chilly rain, and I'll be staying in cozy inns and B&Bs, so that means sporty, waterproof and warm. Then I'm off to Paris where (no offense to the English countryside) I clearly want to up my game! What's a girl to do? Pack only mix and match items that have at least two or three functions each, that's what!

Here's what I mean:

Yoga Pants: No, really! A heavyweight, boot cut pair of black yoga pants can work quadruple duty. Mine have the ability to wick away moisture and are a matte finish without any sheen. They work for many outdoor activities, especially on a cool, dry day. They can easily serve as a black slack and look adorable and chic when paired with a tunic top and scarf. They make for very comfy lounge wear and are perfect for an overnight flight, AND I can even wear them to do, of all things, YOGA! What a concept!

Convertible Hiking Pants: I lead hikes for a living and I'm in love with these pants. They are 'convertible', meaning they can zip off above the knee and become shorts and are, literally, made for outdoor sports. The fabric is extremely lightweight so they pack away beautifully and can be washed in the sink at night and be totally dry by morning. They're water resistant and even have an SPF rating of 30+. Pair them with your walking shoes and a T-shirt and you have an adorable pair of cargo pants (or shorts) that are perfect for a day of sightseeing, rain or shine! Take them one step further by throwing on a wedge or dressy flat, a sleek tank top, and a sweater around your shoulders. Add a pretty belt and a couple bangles and you're set for a casual night out!

Plain Black Walking Flats: I bought a pair of solid black, rubber soled, slip-on/lace free flats

that are specifically made for walking. They are unbelievably comfy and very simple in appearance, which is what makes them so versatile. Mine can be worn with a strap that goes across the top of the foot, Mary Jane style, or the strap can be flipped away and tucked behind the heel for more of a ballet flat look. I love that! But here's my trick: I went online and searched 'shoe clips'. These are small, clip-on embellishments that snap onto the top front (aka 'vamp') of your shoe and take it from simple to sophisticated or from day to evening in one easy step! They come in lots of colors and styles, from understated little bows and flirty flowers to sparkling rhinestones! I got two different styles of rhinestones: a white rectangular and a small, round, multi-toned blue. Now I've suddenly got three pairs of the most comfortable and adorable flats you can imagine that easily pair with everything from jeans and cargo pants to dresses! It's one more way of adding a little splash of interest and color to my predominantly black wardrobe, and it's an inexpensive, and possibly safer, alternative to wearing jewelry when that may not be so wise. LOVE them!

So those are three of my wardrobe selection tips. I'm only bringing three pairs of pants, total, and only two of them get packed. I'll be wearing my yoga pants on the plane with a pretty, cozy tunic and a pashmina scarf which doubles as a blanket for the flight. I'll be comfy

enough to sleep (fingers crossed) and won't look as though I'm walking through Heathrow in my jammies (not that there's anything wrong with that). I'm also bringing a long T-shirt dress and a second tunic. I really love the tunics as they totally change the look of my yoga pants and jeans, and can be worn alone as dresses w/ tights and flats (but wouldn't that outfit also be unbelievably cute with... oh, I don't know... my RIDING BOOTS?). I'm including a trio of UNIQLO 'AIRism' silky black, breathable, wicking undershirts for layering with everything. One is a long-sleeved mock turtleneck, another is a short-sleeved scoop neck, and the third is a tank... all three easily pass as outerwear, weigh only a couple of ounces and pack away to almost nothing. My Doc Martens are coming along as well. My one "luxury item" is a dress that I'm absolutely in love with. It's a recent thrift store find and makes me feel like Juliet Binoche in Chocolat! I have a dinner cruise down the Seine for which I hope to look especially nice and I'll be wearing that dress... with my embellished black flats, of course! All in all, with only five main items of clothing in my suitcase, I'll have well over 20 different looks. Not bad, right? Oh, and in the interest of full disclosure, the jury is still out on the boots.

What are your best packing tips and trip essentials? Please comment below!

By the way: I'm leaving in only a few days

and will have some extra posts coming up! We're about to do this!

Thought for the day:
*'HE WHO WOULD TRAVEL HAPPILY
MUST TRAVEL LIGHT'."
~ANTOINE de SAINT-EXUPERY~*

March 27, Fifth Entry:
"CROSSING THE POND: A TEAR IN THE TIME/SPACE CONTINUUM

It began on the morning of Thursday, March 19th, the long trek to England from my hometown in CA. My sister and my niece dropped me at the airport bus. The bus took me to LAX. Air New Zealand took me to London. When broken down into segments it was really that simple.

Upon arrival, I went right through customs, sailed through immigration, got my SIM card for my cell phone, everything went exactly according to plan! OK, almost everything. I don't really want to talk about my fledgling experience with the London trains and Underground system but, in an effort to get from the airport to a small village in the Cotswolds, I went from Heathrow to Kings Cross/St Pancras, to Euston Station, to Northern Railway, back to Kings Cross, to Piccadilly... No wait... Paddington, took the Piccadilly Line... Or did I take the Piccadilly Line to Paddington? I honestly don't remember, but I finally ended up on a train that took me to some tiny village very near the village I was going. I arrived in the late afternoon on March 20th, the Vernal Equinox, aka: the first day of Spring. Now I assure you, after this trip I felt like a lot of things... 'The First Day of Spring' was not among them.

Lessons for the day:

1) Trust the thorough research I'd done at home regarding the train service. Had I done so and followed my step-by-step instructions, I never would have gotten lost. Instead, I second guessed myself and asked every ticket agent the best way to get to my destination and they all had a different opinion.

2) Arriving at a new place in the morning is a really good thing. It took much longer to get to my inn than anticipated and I still arrived well before dark.

So, yup, I got totally lost, cried twice (chalk it up to fear and utter exhaustion) and, a mere 29 hours after I woke up, I had reached my destination, meeting some very lovely, compassionate, helpful women along the way.

It's a very strange experience stepping onto an airplane, taking an overnight flight, adding an eight-hour time difference, emerging on another continent, on a different day and, in my case, in a new season! If that ain't time travel, I don't know what is! Sort of Back to the Future meets The Wizard of Oz. If all that isn't odd enough, I understand there was also an eclipse! At least that's what I was told upon arrival but who the heck knows? The young man who was putting the new SIM card into my phone and checking that it loaded and worked properly was making polite conversation and told me I'd just missed an eclipse. My response to hear-

ing this was a blank stare, a pregnant pause and an 'oh?' He could have told me I'd just missed seeing Big Foot stroll through the Queens Terminal, my reaction would have been exactly the same. You see, sleeping on airplanes isn't something I'm particularly good at so, at that point, information just wasn't being efficiently processed. I was hungry, I was dehydrated, but mostly, I was TIRED!

As entirely depleted as I was, I found the journey on the train from London through several small towns in the Cotswolds, via Oxford, to be extraordinary. As the train pushed further away from the city and deeper into the countryside my eyes began to well up. Yes, sorry, more crying... But this time the tears were filled with joy and came with the uprising of emotion as one witnesses, in real time, a dream being realized. It was all so beautiful! Just as I'd imagined since I was a child, and a thousand times better! I saw what looked like a castle in the distance. I saw miles of rolling fields with stone wall boundaries corralling sheep and new spring lambs. Magnificent draft horses grazed in the sunshine. There were swollen, rushing creeks with arched wooden bridges. Then suddenly, I laid my eyes on the spires and towers of the University of Oxford, and I literally gasped. I whispered under my breath, "What is tha...? Oh my God. It's Oxford".

That's the moment it really hit me. I was really here. I did it! I made it! I was in England! I was

on a train in the UK crossing the English countryside and I was looking right at Oxford University. That's when the tears came. They surely weren't my first of this trip. They would not be my last.

Thought of the day:
'YOU DON'T NEED MAGIC TO DISAPPEAR, ALL YOU NEED IS A DESTINATION'."
~UNKNOW

CHAPTER TWELVE
Broke

Sitting across the cluttered desk, the coldness of the metal folding chair creeping through her tight jeans and into her flesh, she gazed at the woman who asked perfunctory questions while filling out the necessary forms. She was painfully aware that, although physically speaking, the standard issue desk -- the same one that belonged to every school teacher she'd ever had – was all that separated the two of them, a much wider chasm lay between them. The woman, with her advanced collage degree – sociology with a minor in business, she guessed – her municipal job with its comfortable, steady paycheck and comprehensive benefit package, was the picture of stability and good choices, a closet full of smart looking sweater sets and slacks at

home, no doubt – ones that still fit. And she, on her side, was poverty and need. She'd come here, laying out the sad hand of cards she'd long held so tightly to her chest, finally exposing the humiliating reality of her situation. Insolvency comes with a comprehensive benefits package of its own: Don't get sick.

She was falling into the trappings of an extended period of underemployment and joblessness. She had to cut her own hair, her curls masking the multitude of scissor related sins committed against them, or so she hoped. Her eyes and skin were dull and empty reflections of her lifestyle, their healthy glow fading with her options. Her "nice" clothes didn't fit anymore, her weight having crept up because buying salty, fattening garbage at the grocery store is just cheaper. You can get a hell of a lot of pasta, in all its nasty forms, for a fraction of what fresh vegetables cost. Five dollars could either purchase six or seven pounds of dry pasta which, even in a state of depressive overeating and too much time on your hands, could feed you for a week, its carb laden construct bathing you in comfort and lethargy. And at thirteen to nineteen cents a pop, that same five bucks could get thirty or forty bags of ramen, pasta's chemically synthesized, sodium laden cousin. Or, it could buy two heads of lettuce. The choice is yours. When you have little money and an empty belly, you do what you have to do.

What the women did share was an emotional detachment as, question by question, her bad luck story filled her file, soon to be stacked atop all the other folders in a paper tower of hardship and woe. No one leaves this room with any sense of pride – in fact, no one holding any real amount of pride can enter. Pride and optimism are the invisible barriers surrounding this building and, in desperation, they were what she'd had to cast aside. An offering of transparency and defeat being your ticket in, a cost that further eroded one's sense of self-worth. It was a vicious downward cycle.

"Are you working now?"

"No."

"Are you looking for work?"

"Yes."

"When is the last time you had-full time employment?"

"August of last year."

"So, about 15 months?"

"Yes."

"How much were you making?"

"$30,000 a year. Before taxes."

"Are you collecting unemployment?"

"Yes."

"How much?"

"$204 a week."

"You were making $30,000, why so low?"

"When I lost my job I thought, with my ex-

perience, it would be fairly easy to find work so I didn't apply for unemployment. I was naïve, I guess; seems the market has changed quite a bit. The only work I could find that paid more than $10 an hour was part time. The owner said it would turn into full time after a few months, with benefits. It took me four months just to find that, so I took it. The unemployment is based on what I was making there."

"You no longer work there?

"No."

"What happened?"

"It was a start-up and they didn't make it."

"Do you have any savings?"

"Not anymore."

"Is that how you've been supporting yourself? With your savings?"

"Yes. And the unemployment."

"Do you have any other sources of income?"

"No."

"Is there anyone you can ask for financial help?"

"No."

"No family or friends?"

"No. No one I can ask."

"Are they unable or unwilling to help?"

Her head drops and she stares at her lap.

"OK. Do you rent or own your home?"

"Own."

"Are you able to make your mortgage payment?"

"No."

"When was the last time you made a payment?"

"Last month."

"So, you can't pay it this month?"

"No."

"Have you missed any other payments?"

"No. I used my savings."

"Anyone paying you to stay at your home? Do you rent out a room or anything like that?"

"No."

"No one else contributing to household or other expenses?"

"No."

"How many people reside in the home?"

"Just me."

"Have you thought about renting out a room to supplement your income?"

"No, it's just a tiny one bedroom."

"How about utilities? Are you able to stay current?"

"No."

"How far behind are you?"

"Two months on electric. Three on my oil plan."

"Oil. Is that the heat?"

"Yes."

"How much in the tank right now?"

"Not much. Less than a quarter tank. They said they can't make the delivery until I bring the account current."

"Are you able to do that?"

"No."

She goes silent but continues typing for several minutes.

"OK, so here's what I think we can do for you. I can make a request for emergency funds so we can get your mortgage paid this month but that's a one-time thing. We won't be able to do that next month so you're going to have to figure something else out. You qualify for the fuel assistance program so I'm going to apply for that today. We can get your oil tank filled, probably in the next day or so, and the state will cover the cost. We'll also make sure they don't shut off your power and water. Here's a list of food pantries. Some you need to call and sign up ahead of time, others you just show up. Go and pick up some food. It's donation based so they won't have anything fresh, mostly canned and dry goods but it'll help. I encourage you to apply for government assistance. You're living well below the poverty line and there's help for you. I encourage you to take it. You'll qualify for the SNAP program – do you know what that is? 'Supplemental Nutrition Assistance Program'… food stamps. You'll have to go into the city to apply for that. On the second page you'll see the address. Go to their website to find out what you need to bring with you. There's no sense going if you don't bring everything you need because they'll turn you away. No exceptions. Go online, do you have internet?"

"I turned it off."

"Then go next door to the library, you can use the computers there. Do you have a library card?"

"Yes."

"OK. I think that's it."

"Thank you. I really appreciate it."

Outwardly, she expressed relief and gratitude, forcing a pathetic smile, while trying in vain to conceal her insides shrinking with humiliation. A sense of smallness sliding down her chest into her gut, taking her eyes and head down with it.

"You're welcome. Make those appointments. Do it today. Don't wait."

"Thank you. I will."

She opened the door just wide enough to slide out sideways, closing it behind her as quietly as she could. I'm living "well below the poverty line". "Well below" – talk about an oxymoron. She walked with an invisible sign on her back; "INDIGENT" it read. This is what shame feels like; conspicuous and unworthy of eye contact.

♥ ♥ ♥ ♥

The Department of Social Services. It took three tries to make it inside the gargantuan brick building. Covered in dust kicked off the highway that separated it from city dump, chain link surrounding the parking lot, guards at the entrance. The first time, at 7:51 am, she was turned away at the gate. There were already too many people in line and they wouldn't be able to get to everyone as it is, the guard told her.

"Sorry, Lady. You gotta get here early if you wanna get inside."

"But they're not even open yet."

"You gotta get here EARLY! Like seven-thirty."

The next morning, she arrived at 7:25 and parked in the lot, waiting in line for about ten minutes before a guard came out and started a head count, stopping about fifteen feet shy of where she stood.

"OK, that's it!" he shouted, "we're gonna be full! Everybody from here on back go home. Try again tomorrow."

She did as she was told.

The third time, she left her house before 6:15 am for the twelve-mile drive. With traffic and a winter storm setting in it would be slow going. The storm turned out to be both a blessing and a curse. Fewer people showed up but there was no shelter in the line. So, there she stood, about forty people deep, sleet and freezing rain coming down on them – but today, she would get inside.

With nowhere to go for a while, conversations were struck in line. She was ashamed of herself for being surprised that the others there with her were not what she expected. They exchanged war stories, finding an odd comradery in their hardship.

There was the doctor. He had accepted an invitation to practice at one of the teaching hospitals just outside the city. He'd uprooted his family,

moved them here and, with budget cuts, lost his position in the first year. "Last in, first out, I guess." Like everyone else, he'd been unable to find a new post in the sliding economy. There was the college professor. He taught at one of the prestigious universities but when his mother fell ill, the cost of outside help was as much or more than he was making as a teacher. He'd left his job to care for her, the long-term illness draining their savings. There was the stay at home mom whose husband had walked out, leaving her with three children to care for. The jobs she could get barely covered day-care for the little one, let alone household expenses, even with the child support payments.

She listened to these people tell their stories then shared her own: She'd been recruited from across the country to be a project manager at an award-winning firm, but she was let go just shy of her one-year anniversary and only six months after she'd bought her small home. Further confiding that, without a bachelor's degree, she couldn't even get an interview for jobs she'd been doing for years. The fact that it didn't seem to matter to the employer what the degree was in – just that you had one – seemed ludicrous.

Early in her job search, she'd gotten tipped off about an inside track opportunity. A spot was about to open up for a superb, mid-management position that was right in her lane and promised

a healthy bump in pay. A friend and professional colleague knew the owner of the company, sending her in with a personal referral and glowing recommendation, telling her she was a shoo-in. "Go shine!" she'd told her, "it's perfect for you!"

She'd strode into the building, feeling like a million bucks in her brand-new suit; the jacket and trousers in a subtle black and white tweed read traditional with a contemporary edge. A crisp burgundy button down with the tiniest pleating along the placket and matching low-heeled, suede sling-backs added a touch of panache. Her hair, make-up and accessories were kept sleek and understated. She looked polished, professional and strong. Like a "results oriented, creative self-starter who could think outside of the box!"

After sailing through the first two interviews with HR, she was told, "While you're here, let's get you in front of the department head. He's in today and I think he needs to meet you sooner rather than later." That meeting went so particularly well, the boss speaking to her in terms of a done deal, she honestly believed the job was hers. She was really going to like it here! After touring the spacious offices, introducing her around and showing her where she'd be working, they were wrapping things up in the conference room, nearly two hours after she'd arrived. Just as she was about to extend a solid handshake, the man held up a finger saying "just one more thing." He

reached over and pulled up the shade-like projection screen, revealing an enormous, convoluted, algebraic equation written on the dry erase board behind it.

Then he posed the question: "Do you know how to solve this problem?"

Oh, God, no, no, no. This has to be a joke! What do I do? Just be honest. "Sir, I won't misrepresent myself, I don't think I do."

"Well, what if I said you had to solve it? What would you do?"

"I would do my best to figure it out."

"You'd figure it out?"

"I'd do my best."

"Then go ahead, try to figure it out," he handed her a dry-marker. "I'll tell you what, if you solve this problem, the job is yours. If you don't, then I won't hire you."

She stared at the board and felt the blood drain out of her head. She wanted this paycheck so bad but there's no way she could solve this... few people could.

He stood there and watched her flounder at the board for a few minutes, then said, "You're not going to get it, are you?"

"No, Sir, I don't think so."

"The job is hanging on it. What are you going to do?"

She was gutted. "I think that if my employment

here is based solely on my ability, or lack thereof, to solve this equation, then... then I'm not going to get this job."

She tried desperately to maintain a professional veneer and swallowed back her tears as she felt opportunity slipping through her fingers.

"Nope, I guess not. Too bad, you'd've been great!"

"With all due respect, Sir, may I ask if advanced mathematics is a requirement for this position?"

"No, of course not."

"Then I'm afraid I don't understand."

He proceeded to confess there was no correct answer, the equation was unsolvable, he'd made it up.

"And I'm truly no longer being considered for this position?"

"Nope, sorry."

"Forgive me, but I'm confused. How does the inability to solve an unsolvable math problem, in a position that has no requirement of advanced mathematics, preclude me from consideration?"

"Well, it seems YOU don't know how to ask for help."

"Pardon me?"

"You didn't know how to do the math and you didn't ask if I could help you."

"It didn't seem like an option under the circumstances."

"If I hire you and you come across something you don't know how to do, how much of this com-

pany's time and money are you going to waste by not asking for help?"

"Well, if I encountered that situation during the course of my workday I would, initially, try to solve the problem myself and if, after a reasonable amount of time and a certainty that it was beyond me, of course, I'd ask for help."

"Yeaaah, but you didn't."

"Sir, I know I'm qualified for this position. I can do this job and I can do it well."

"It was nice meeting you. We'll be in touch," he said. She was dumbstruck.

Just like that, it was gone. Although her subsequent interviews were far less dramatic, the results were no more encouraging. The slow erosion of her confidence and financial resources had begun.

And where the sidewalk met the wet morning gray of the sky, as the soft patter of sleet fell on and around her, conversational thoughts passed through her mind. An internal call and response; "How in the world did I get here?" she asked herself.

"You walked," came the answer.

"I walked?"

"As sure as placing your feet on stepping-stones, one after another, you walked here."

What she was doing, the path she'd been taking, every choice she had made, had led her right here. To the front stairs of the State Department of So-

cial Services, standing in a slop of freezing rain, waiting to apply for food stamps.

"But I thought I was making the right choices, smart choices for my future."

"Yet those 'smart' choices, meant to put you on the path to success, have put you on welfare."

"How is that possible?"

"You chose the wrong path."

"Wrong? When you're an adult you do what you have to do, you don't have to love it, you just do it, right?"

"It was wrong."

"How was I supposed to know that?"

"Did it feel right?"

"It felt forced."

"Did you like it?"

"I hated it."

"The Universe was trying to tell you something."

"I'm a failure."

"You failed because you ignored your purpose."

"What's my purpose?"

"Follow your passion. It's your reason for being here."

"But I can't make a living doing it."

"You're not making a living now."

"Follow your intuition," her mother had once told her, "it's there for a reason."

Once inside, meeting with a counselor, she was reminded that right next door at the Department

of Labor there were programs available to her, job training of every kind imaginable. She had been told this months ago when she applied for unemployment but had ignored it, she already had training as far as she was concerned. But this time she was listening. If there was something she really wanted to do, any viable career path with an accredited training program, even if it wasn't on the list of approved trainings but the counselors agreed that it would improve her ability to support herself, they would submit a request to have the state cover the cost. Amazing. She stood precisely on the spot where life could pivot.

Was it an accident that she couldn't find a job? Even if they're consciously unaware of it, people are drawn to those who are doing what they love. Conversely, they are repelled by someone who is doing something because they have to. Either way, whether you want them to or not, whether you know it or not, others are affected by it and respond to it.

"What are you going to do now?"

"If I walked here, I can accept some help, take advantage of the programs they offer and I can just turn myself around and start walking somewhere else."

"If you're going to be broke and on food stamps, you can be broke and continue forcing yourself to do something you hate or be broke while constructively perusing your passions."

"It would be so much easier to move with the current than to continue swimming upstream."

"What if you took all the energy you're dumping into being something you feel you're supposed to be and invested it into becoming something you want to be?"

"There'd be no stopping me."

"Bingo."

The truth, and she knew it, was that she would never, ever, have quit her job and taken a leap of faith. She was pushed and she had walked, and maybe she was led, but regardless of how it happened, now that she's arrived, everything she knew was going to change.

"Come to the edge.
We might fall.
Come to the edge.
It's too high!
COME TO THE EDGE!
And they came
And he pushed
And they flew."
~Christopher Logue~

CHAPTER THIRTEEN
The Ahhh Factor

The "Ahhh Factor". It's the gauge I use to measure my physical and emotional response when I enter a spa. It's the level of instant relaxation, comfort, and serenity I experience, the tranquil little journey I've taken just by walking through the door. Is it the delicate music? The décor? The intoxicating hint of essential oils coming from... somewhere? Whatever it is, I sometimes feel as though I've just entered another world. A world where, suddenly, I no longer care about the guy who almost ran me over in the parking lot or that six people are coming for dinner tomorrow and I've yet to start shopping. Who cares? I have, at least for an hour or two, left that world behind. I've arrived for my treatments and, right now, that's all that matters.

The town I call home boasts a major "Ahhh Factor". Just go walking in our parks or gazing at our mountains and you'd know what I mean. Your mind starts to clear, your breathing slows and your shoulders journey away from your ears. Take a deep breath... Ahhh.

My little town has, arguably, won some sort of geographical lottery and it's clearly a pleasure to be here for any length of time. But regardless of where we live, even if we're lucky enough to live someplace really beautiful, life can get stressful. Work, traffic, bills. The usual suspects, and a lovely view does nothing to keep heartache and sadness away. Those things can find you anywhere. Just like they found me.

Let me share with you a personal story about, what was for me, the healing power of touch.

Many months after suffering tremendous heartbreak, I took a trip with a girlfriend. A much-needed spa weekend.

While planning our trip, she read to me from the hotel brochure the description of their "signature" treatment. In poetic and seductive detail, it described the wonderment of luxury and indulgence that was to be mine for close to three hours. "I want that! How much is it?"

After some deft twenty percent calculations, we figured we wouldn't get out of there for much

under three hundred dollars each. "A hundred bucks an hour?"

She reread one of the passages. I was no match for this brochure. "I'm in! Let's do it!" We made the conscious decision to spend, no, *invest* the money in our own wellbeing, with no regrets and to enjoy every minute of the weekend.

The resort was a Zen paradise with bungalow style rooms, connected by meandering pathways through lush gardens. We ate salads at a casual alfresco restaurant, watching the sunset gather colors and begin its nightly show. Finally, it was time for our treatments.

The spa was exotically beautiful, the receptionist and therapists were sweet, soft spoken, impeccably trained and professional. They made us feel as though our appearance was the highly anticipated highlight of their day. We arrived early, as suggested, and enjoyed a swim in the pool and a soak in the Jacuzzi prior to being led to our dimly lit, private treatment rooms. "Have fun! See you in a few hours!" We bid each other goodbye. We were in fluffy robe heaven!

The treatment ritual included a body scrub, a deep conditioning hair and scalp treatment, a thirty-minute soak in the most beautiful wooden tub I've ever seen – it sat atop a bed of smooth gray river rock, translucent discs of essential oil and rose petals floating on the surface of the water –

and a sixty-minute massage. After the emancipating molt of my sugar-scrub and scalp treatment, the therapist exited the room and left me to rinse under the rain-shower, then sink into the dark steamy tub. As I sat there, bathed in rosewater and candlelight, listening to the spare plinking of the Asian music and sipping my tea, I began to weep. Not sad tears; they were tears of joy! I felt warm and safe... and *good!* I felt so good! I was present. In the moment. Not longing for another time or place. I wanted to be right where I was. I had allowed myself to surrender to the experience, to absorb every drop of nourishment, bathe in the exotic fragrances and be transported by the music. And it felt so good to be touched by another human being. I hadn't realized the deprivation of touch I'd been experiencing until someone actually touched me. Safe, intentional, human touch. In that moment I wished that every person in the world could know how this feels, at least once. I somehow felt a convergence of total escapism while feeling wholly grounded and in my body.

I gathered a handful of rose petals, brought them to my nose and breathed in their heady bouquet. As I released them into the water, I whispered into the darkened room, "this was worth... every... single... penny..." a smile moving across my lips as I slid down into the hot water past my earlobes. This was bliss. And I still had a massage

coming!

In our lives today, we often neglect to take time for ourselves. Some see it as a luxury. Not true, in my opinion. Unless we take good care of ourselves, we won't be able to perform to our optimum ability or take the best possible care of others.

I'm not suggesting that every trip to the day spa will allow us to transcend but I'd love to open up that door and nudge you toward it. Our first step is a willingness to explore the possibilities. So, let's turn off those cell phones and begin our journey! Ready? Take a deep breath... Ahhhh.

CHAPTER FOURTEEN
The Clean People

The Clean People. That's what I called them. Maybe you have your own name for them? The people on the other side who aren't you. They don't appear to have your burdens or secrets, living a life unencumbered.

The Clean People were out in force every morning. They had showered, eaten breakfast, they'd slept plenty... in beds, on crisp, freshly – or at least recently – laundered sheets. *They had slept.* While I was out all night destroying my life, they were tucked in safe at home, getting eight hours of restorative sleep. They had jobs, coworkers, paychecks. They walked around, out in the sunlight like they belonged there, with nothing to hide. They laughed, talked to other Clean People,

looking them in the eye. They would eat lunch, either at a restaurant or something they had the forethought and wherewithal to pack in advance. They would go home at night and have dinner with their families, watch some TV, sleep all night in their clean beds and then do it all again. Those fuckers. They were everything I wasn't. I was everything they feared. I resented them. I pitied them. I hated them. I envied them. I wanted desperately to be one of them – but I wasn't. *I just wasn't.* This was my lot in life and I needed to accept it, there was nothing to be done about it. I watched them through glass that was dirty only on my side, hoping I was hidden out of sight. I'd surely disgust them if they saw me. I disgusted myself.

The newness of morning and the start of another day, full of possibilities, that was their world and I didn't belong. Like other nocturnal vermin, I was hiding. Lurking in the shadows, praying not to be seen. Skulking home in the morning like a rat or scurrying like a cockroach at the vibration of approaching footsteps and the threat of light. They were the Clean People, smelling like soap and shampoo, shaving cream and cologne. I reeked of cigarette smoke and alcohol. I was dirty. The stink went clear to my core. I'd slept little or not at all... again.

Sunrise; the horrid in-between of an alcoholic's world. Still drunk and already hanging over, it

was tomorrow with last night still unwashed and clinging. The gift of oblivion crashing into the fear of what I may have done. I was sick, shaking, sneaking, trying to travel, unseen, before the sun came up to wherever "home" was at the moment. I had no home of my own. The only thing worse than how I felt was getting caught by the sun before making it back to where I'd hide until darkness came once more, luring me out of my hole and back into the night, doomed to break the promise of "never again".

But the dawn broke. The shift changed. The "invisible" spell wore off and the veil that separated our worlds became permeable. The Clean People and the Dirty People could catch glimpses of one another, forcing the reminder that the other exists.

It was on one of these mornings that I'd caught my reflection, a glimpse of what I'd become. Holed up in a forgotten trailer on a stranger's property and unable to sleep, I unexpectedly faced a mirror. Initially I didn't recognize myself, then sat horrified at my own image. It was me, but not. The bright-eyed, willowy girl with cascades of auburn hair, irrepressible laugh and beaming smile was long gone. I gasped. What I saw was a ghost, sunken in on herself. Gaunt, fallen cheeks, hollow circled eyes, simultaneously emaciated and bloated. My pupils so dilated I had no iris, only huge black holes in the center of my empty

eyeballs. How could I not have seen it before now? I cried out to the Universe, desperately begging for help. Someone, *anyone*, please, what's happening to me? God always hears the cries of the tortured soul, right? No one heard me. No one came but I knew I needed saving; soon it would be too late. I would do it myself. I would have to go out into the sunlight to find help. Intentionally reach my hand through the barrier to the Clean People. I was that desperate.

I grabbed my few belongings and ran. I needed to get to a phone to call for help. I knew the neighborhood, it was the one I had grown up in and there was a park nearby, maybe half a mile away. I'd been up all-night drinking and doing drugs, just like the night before and the night before that, catching an hour's sleep here and there. I was shaking, depleted, paranoid (*"they" were after me*) but I kept running.

Just inside the park was a restroom and I ducked inside to hide for a moment, catch my breath, collect my scattered thoughts. There was a mom with a little girl at the sink washing hands and I hid in a stall, locking the door behind me. The mom and the little girl were not what they appeared, my crazy, spiraling brain told me. They were Feds. Federal agents sent to watch me, to catch me. I truly believed this. But I was wise. I was watching them, too, peeking through the crack in the door, waiting for them to leave and,

surely, file their report. Once they were gone, *those spying fuckers,* I crept out of the stall, past the sinks, out into the dappled sunlight of the patio to the payphone. I squeezed the dime I'd found in the corner of my purse between my thumb and the knuckle of my pointer like a vice, slowly creeping up on the phone. *Bees.* I saw bees flying around the phone. Where they real? The morning sun was so hot and bright I couldn't be sure. "HEY!" Nearly jumping out of my skin I whipped around and, *oh God, no.*

A girl I knew from high school stood there grinning at me. "Hey!" she repeated more softly, a little out of breath, "I thought that was you... didn't mean to scare you!"

"HI," I said.

"We're playing softball and havin' a kegger on the field, you should come down!"

"Oh, no thanks, I... I have to make a call," I nervously gestured to the phone.

"So, come down when you're done! It's just a bunch of locals, you know everybody, and there's tons of beer. Never too early to party, right?" she bit her lip and clinched her fists, slowly dancing in place in an attempt to make me laugh.

"I really can't, thanks."

"Well, speaking of beer, I gotta go..." she laughed, pulsing her thumb toward the bathroom and disappeared inside. I'd wait until she was gone.

She came out and saw me still standing there. "No phone call?"

"Busy," I said.

"Oh, right. Anyway, we're down there. You should come!" She turned to leave (thank God), then stopped, "Hey, are you ok? You look kind of..."

"Yeah, I'm just... I think I'm getting the flu or something."

"Oh shit. Hangover, huh? That sucks. Well... 'hair of the dog'!" She pointed again with her thumb toward the ball field. "Later!" and she was gone.

Once I was sure she wasn't coming back, I turned to face the phone, the light swarm of bees floating around it, dreamlike, my knees about to buckle beneath me. I slowly reached out and took the receiver, praying not to be stung by one of the creatures that may or not be real, put in my dime and listened while it dropped. I dialed and held my breath as it began to ring. The words I was about to say would be life altering, ending life as I knew it and throwing me headlong into a new one. I was about to spill it... to tell on myself and there would be no going back. This was a bell that, once rung, couldn't be unrung, and I knew it. Tears brimmed over the puffy red rims of my eyes.

"Hello?"

"Sis?"

"Hi. You alright?" she could already tell

"Can you come get me?"

"I guess. Where are you?"

"Manning Park."

"On San Ysidro?"

"Yeah, across from the Y. Sorry." She lived on the other side of town.

"Are you OK?"

"Um," *say it*, "not really."

"What's wrong?"

"I don't know. Nothing. Everything," I tried not to sound like I was crying

"What is it? Are you hurt?"

"Sort of. Yes."

"Did someone hurt you?"

"Yes."

"WHO HURT YOU?!"

"Me."

"What? What are you talking about?"

"I hurt me. I keep hurting myself and I can't stop."

"How are you hurting yourself? Do you mean the drinking?"

"Yes. But it's more than that," *here we go...* "I've been doing drugs, too."

I could hear her breathing.

"What kind of drugs?"

"Cocaine. Pills. But mostly coke... a lot of it. I can't stop. I've tried to stop, for a while, but I can't."

"Well... that explains a lot."

"Sis?"

"Yes?"

"I think I need help." And there it was. With five little words I'd raised the white flag and stopped the madness.

"I know you do. We'll get you help. It's going to be OK, you hear me?"

"Yes. I don't feel good," I was openly crying now. I had jumped and my big sister was going to catch me. Her protective instincts had taken over. Relief poured in.

"Will you be OK 'til I get there? Do you need to go to the hospital or anything?"

"No. I just want you to come get me."

"OK, I have to drop off the girls and I'll be there as soon as I can. Don't move!"

"I won't. I'll be at the picnic table near the parking lot."

"Sit tight. I'm on my way."

"Thank you. I'm sorry."

"Don't be sorry, just don't move. I'll be there as soon as I can."

PART II
Continuum
Epilogues and Lessons

CHAPTER FIFTEEN
Continuum

"Starting over". "A new chapter". "A clean slate". What does that even mean? Seriously, it all sounds so fresh and cleansing but, barring an extremely rare case of total amnesia, you can't really start a life over, can you? Regardless of what we must endure, there is a continuum – an invisible line in a person's life connecting past, present and future.

The line that ran through my life wasn't an elegant, silken thread. Mine had become an inextricably tangled, balled up mess, yet the line remained unbroken; it still ran end to end. It would be easier if there was some clear definition, some delineation between events on which you could simply close the door, but no matter what hap-

pens, we pick up the pieces and we march on. Eventually I marched on, dragging a nasty ball of circumstance, mistakes and catastrophes along behind me.

The larger the burden of my past had become, the more it took on a life of its own and the less room there was for me to live in the present, let alone hope for an unencumbered future. I'd become the battered result of what I had lived through. Instead of granting wisdom, the ghosts of my past had become a sycophant, occupying my space and sucking my air, leaving little room for who I'd started out to be.

No matter how many clichés there are to the contrary, it's extremely difficult to simply "let go". The mind has a funny way of looking backward, revisiting and regurgitating, so that it's very hard to (here's another one) "make a clean break". But I had to try. The mistakes, the hurts, the heartbreaks, the betrayals (mine and others), I wished I could have just stepped over them or walked around them like dog poo on the sidewalk and kept on going, forgetting about it a minute later – but I couldn't. I had stepped in it and it stuck. No matter how I tried to scrape it off or wash it away, I'd be riding in my car or sitting in a waiting room minding my own business when, like a bad smell, it would creep back on me. It made me feel self-conscious and withdrawn.

Let me go back and tell you a little bit more about myself. Actually, reintroducing myself may be more accurate as you already know more about me than you may realize… a lot more.

CHAPTER SIXTEEN
Tipsy, Part II

My name is Amie. I'm the author of this book you're reading. We met once, you and I, in the mid nineteen seventies, when I was a girl of about eight years old. My soon to be best friend and I found one another on the school bus when my family moved to a small New England town. She and I had immediately become inseparable in what I can only described as an idyllic childhood, running free in our beloved Connecticut woods. Several years later, after my family moved away to California, I visited her and together we had our very first sips of alcohol. Yes, that was me, the younger girl in chapter two. I got drunk the first time I had a drink, and with few exceptions, every time after. It happened over and over, hundreds of times. I didn't know it then,

but I had very low self-esteem/identity, was extremely sensitive and have an addictive personality; a trifecta of vulnerability. Within three years of that first drink, I'd developed a serious problem with alcohol. Within five, I was an out of control, fully addicted, black-out drinker.

CHAPTER SEVENTEEN
The Clean People, Part II

We also met a decade later, in chapter twelve. At twenty-five years old and after more than ten years of drinking alcoholically, adding a variety of drugs into the mix, I'd hit rock bottom in an abandoned trailer in Montecito, CA, less than two miles from my teenage home, and came clean to my family about the true extent of my drinking and drug use. I'd called my sister from a payphone in the park accompanied, or not, by a swarm of bees. To this day I honestly can't tell you if they were real or if I was having some sort of metaphoric hallucination.

The wait for my sister to arrive felt like an eternity. Having intentionally distanced myself from those closest to me, seeing me must have come as

a shock. I looked like death warmed over. Understandably, she had a lot of questions. I was humiliated but answered honestly, finally unburdening myself. I'd been lying for so long, trying to hide my secrets, that the truth, as awful as it was, felt good to tell. She wanted to know if I still had a job, I admitted I'd been fired a few months back. How was I supporting myself? I'd gotten an eight-hundred-dollar severance when I was let go but had nothing left. How was I paying my rent? I confessed I no longer had a home. Where was I sleeping? Where was all my stuff? I'd kept bits and pieces of my few belongings in the same places I crashed; at various friend's houses and in my car. Sometimes I slept on the beach. Visibly upset, she paused for a minute to take it all in, then her protective nature took over. "I know you feel like shit," she said, "but we're going to get all your stuff right now. No argument. After today, you are never going back to those places again."

We collected all my shabby piles of worthless crap. Two plastic garbage bags stuffed with clothes from one place, a banged-up suitcase-full from another, a couple of torn paper bags and various armloads from the trunk of my broken-down car, not worth the cost of repair and, like me, about to be towed away. I hadn't driven the thing in months, just left it to rot in the parking lot at a friend's apartment building. I'd let my driver's license lapse, never renewing it – knowing, if noth-

ing else, that I had no business being behind the wheel of a car. From the backseat where I'd often slept, an afghan crocheted by my Nana - the only thing of any real value - was the last thing I took.

When I was little, my sister would sometimes give me baths before bedtime instead of my mom, promising to teach me silly songs as a bribe to get me in the tub. Together we would laugh and sing, my big sister and I. How hard this must have been for her now. I was so weak by the time we got to her home, she had to help me into the shower. She fixed me something to eat and drink and tucked me into her bed to begin to sleep it off. "I'm going to call mom and dad and let them know what's going on, you can talk to them when you've had some rest, OK? You sleep now. I'll be right downstairs." Exhausted, I passed out until late evening.

"Are they mad?" I asked my sister before I phoned.
"They're not mad, they're worried... and they're relieved. They've been waiting for this call for a long time."

She was right, our parents had been longing for this day for years. They'd read books, contacted professionals, gone to meetings. The advice was always the same and it was torturous... they had to stand by, do nothing, wait until I was ready. This was the answer to their heartfelt prayers, and I was sickened at what I'd put them through, just

hated myself. Ironically, when I started drinking, my self-loathing, the thing I wanted to numb, was imaginary... I'd done nothing to deserve it. But with the abuse of drugs and alcohol came the abuse of those around me, transforming my need to self-anesthetize from fictional to factual. Without knowing it, I was practicing the Law of Attraction; I became what I believed. Then I drank to try to forget my transgressions; existing in a protective bubble of denial that only shielded me. "I'm only hurting myself, right?" But no addict exists in a vacuum, they spew their mess on anyone in proximity. And when you try to stop administering the analgesic the blinders come off, forcing you to acknowledge the damage done. Sometimes it's just too much to take in. So, you don't, you just keep going.

"Tell us everything," they said, my mom on one extension and my dad on another, and I did, well, as much as I could while sparing them the gory details. For once, my damage control was for their protection, not my own. My dad had purchased a one-way plane ticket after my sister had called, and was flying me across the country to be with them. After I'd gotten out of high school, they'd moved back to Connecticut and I'd chosen to stay in California – but now, wholly defeated, I would join them.

In the days that followed, before I left my sister's home for my parents', I became obsessed

with trying to feel "clean". I took everything I owned, what little there was, and I washed it. With the exception of my suitcase which I attacked in the front yard with dish soap and a hose, if it couldn't go through the machine, I threw it in the trash. Sneakers, jackets, a leather purse; I had to try to get the filth off. But like Lady Macbeth, I would learn that this stain was not to be removed superficially; it could not be scrubbed away. It was internal and deeply emotional and would take years of work to be lifted. But it would lift. To this day, and by contrast, I remain thrilled and amazed by how clean I feel after a shower. A gift and a reminder I hope I never lose.

Eighty-five days past my twenty-fifth birthday, the entirety of my worldly possessions in one medium sized, freshly scrubbed pea green suitcase, I boarded a plane to the east coast to move in with my parents and let them help me save my life.

It was late October, nineteen eighty-seven, when I'd left my beloved, warm, sunny, warm, culturally rich and diverse (did I mention warm?) coastal home of Santa Barbara, California where I'd moved when I was twelve years old, a virtual lifetime ago to a kid, and was dropped into freezing cold, landlocked, Avon, Connecticut. Extremely lovely, but at the time, it struck me as dreary, boring and uncomfortably homogenous. That is to say, I hated it.

I remember my first twelve step meeting (and when I say my "first" I mean the first meeting I ever attended with any intention of getting sober, rather than the one I'd attended several years earlier to get people off my back and shut them the hell up). Just like junior high school, my parents dropped me off outside, nervously watching as their youngest child made her way through the heavy wooden doors and, fingers crossed (also like junior high), wouldn't slip out through a window as soon as they drove away. (I was something of an escape artist in my youth, rarely meeting a window I deemed unworthy of egress.) I walked into the meeting dressed from head to combat booted toe in black, clearly matching my mood but in glaring contrast to the pastel washed, unreasonably cheerful church (church!) community room. Some lady "welcomed" me and tried to give me a hug. Dodging her clutches as if she were taking a swing at me, I shot her the stink eye and made a beeline for a seat in the back row with an unobstructed path to the door and, I noted, several windows.

Any sense of relief or contrition I'd felt had left me. Disgraced, physically detoxing and furious at the world, I was not happy to be there, but apparently felt entitled to critique others. I scanned the room and, wow... talk about culture shock... I was sitting in a semicircle of Norman Rockwell caricatures. There were men in tweeds and sweater

vests, leather shoes with laces, women in sensibly colored cardigans, several stitching needlepoint. Some, men and women both, were wearing these grotesque things on their feet. Like a platypus fucked a hiking boot and had a hideous baby... Duck Boots, I would later discover. And turtlenecks... so many turtlenecks. "Oh, Jesus, I said to myself, this is my punishment. I've died and been condemned to L.L. Bean hell." I scowled at the floor, refusing to speak when the "chairperson" asked me in front of *everyone* if I wanted to introduce myself to the group. I did not. What I wanted was for the earth to open up and swallow me whole. I was mortified.

Little did I know as I sat there seething, hating the guts of each and every one of them, that in the years to come these people, in their corduroy pants and oxford shirts, would become my extended family and save my worthless life. They would believe in me until I could believe in myself. A few of them would become my closest, dearest friends. It would take a long time before I would allow myself to trust them, before truly opening up and letting them help me. How could I? They said they were drunks like me but, other than being blatant fucking liars, they weren't like me at all. I saw how they looked and walked and talked; I recognized them. They weren't addicts, they were Clean People. What in the fuck were they doing here?

But if it were true, if they had really been like me and had found a way to become, well, you know, one of them... could they show how to become one, too? No. Impossible.

But it wasn't. It was extremely difficult and highly unlikely, but not impossible. It happened. I became a Clean Person – although I never did come around to churches or Duck Boots.

CHAPTER EIGHTEEN
Insight

I have no excuse for turning out this way. I'd gone from a life of privilege, with parents and a family who love me, to a homeless, self-loathing, ungrateful drunk and addict. I have, however, come to an understanding. I know that things like heartbreak, addiction, loss, sickness, low self-worth etc., don't care where you're from, how much or how little money is in the bank, or who your mommy and daddy are. They will find you and if there's a chink in the armor, they will infiltrate, take over your life and bring you to your knees. It's what you do when you're beaten that counts. I had choices. I could stay down there until substance abuse killed me, making excuses and casting blame, or I could get the fuck up. Fight back, ask for help. I was extremely lucky to

have the support of my family and a few friends, for which I am extremely grateful. How I ever deserved such loving and forgiving people, especially after all I'd put them through, I will never know. But even if you don't have a circle around you, support groups are free, and you can often find friends and a family there.

Here is something I've learned along the way. Blame is bullshit. It's an incredible waste of time and energy and not only does it keep you stuck, but it digs you deeper. If you can take all your energetic resources away from obsessing over, or pointing fingers at, who or what you think done you wrong and shift them into your own progress... Well, let me quote my beautiful and wise mother who told me as I lay in bed one morning, unwilling to get up after, once again, tying one on the night before: "I want you to hear something: It is unbelievable what you are able to accomplish. The lengths you will go to get what you want are truly incredible. Once you put your mind to something, I have seen you move mountains, heaven and earth, to make it happen. If you could just take all that energy and put it into something positive, my God, there would be no stopping you!"

Thank you, Mom. I heard you. It took me years, but that day, when I was curled up in a ball crying, I was listening. You planted a seed and it took root. It was so long ago, yet I still remember.

Thankfully, I was able to tell her so while she was still with us.

Dear Reader, if you have no one to tell you, I'm telling you now; whatever negative thing you're carrying around or trying to keep hidden, whatever is occupying your thoughts and your time, takes an enormous amount of stamina to sustain. It is sucking your energy and taking your power. If it is someone who has harmed you, they don't deserve your time or energy. If it is the loss of someone you deeply love, they wouldn't want that for you. Either way, take back your power. Claim it. Turn it around. Reassign it. Use it for your benefit. Do it now

CHAPTER NINETEEN
White Porcelain, Part II

Three months after I'd boarded a plane for Connecticut to live with my parents, I moved into my first solo apartment. Agreeing it was time to test my wings, we'd found a sunny little one bedroom on a bus line and within walking distance to my new job, perfect for someone without a set of wheels. As I didn't have two sticks to rub together, mom and dad agreed to cosign the lease, but the night before we were to meet with the landlord, I relapsed. I'd stayed out all night so, of course, my parents knew. When I came home in the morning, I expected to walk into an explosion but they barely said a word to me, there was little left to say. I saw, up close, what I was inflicting upon these two people who never asked more of me than to

be happy, something that I was simply unable to do. Irish, English and stoic, my mother sat ladylike and elegant, fighting tears, her stunning face riddled with anguish. My big Italian dad, six foot one, a formidable rock of a man with jet black hair and piercing blue eyes, sat in his leather easy chair, elbows on his knees, hiding his face and his hands, and wept. I'd made my father cry. I was consumed and gutted. We sat in the den, the three of us, our fear, heartbreak and hopelessness uncontainable.

I would come to hit bottom many times, in many respects, in an effort to heal. No matter the malady, recovery isn't a fast ride in the express elevator up to the penthouse; it's more like some kid has hit the button for every floor in a skyscraper. To get out and take the long, arduous climb up the steps, I'd learn, would prove the more direct route. Still, it was to be up and down, stop and go, trip and fall, fast and slow, but as long as I kept getting back up and moving, I was getting somewhere. That morning, because I thought I'd get away with taking a shortcut and hitching a ride, the carriage took a freefall back to the ground floor. But crushed and broken amid the pain I'd caused, I'd gotten a good solid kick in the ass, moving me ever so slowly upward from there.

They agreed to get me the apartment anyway, with the condition that I would go to work Monday through Friday, pay all my own bills, and I would attend twelve step meetings daily, no ex-

ceptions, no excuses. It was the best thing that could have happened but, in my petulance, I surely didn't know it at the time. Although I was very grateful to be getting my own place, I was pissed – at myself, sure, but also at the deal I had to make to get it. As I went to my room, I said to myself: "Great. Now I have to go to those fucking meetings every day."

Navigating the radical mood swings that are part and parcel of this journey was dizzying. How would I ever get any footing when the ground underneath me kept shifting? Case in point: Prior to this relapse, I'd been going to meetings a couple times a week for a few months, but hadn't shared much with the group, and when I did speak it was from my newly acquired throne atop my giant fluffy "Pink Cloud". Pink Cloud Syndrome is the false state of euphoria one may experience as part of the novelty of being recently free from drugs and alcohol. "Problems? What problems? I've kicked the habit! I'm all better now and everything's fantastic!"

Although you feel on top of the world and the view is lovely from up there, beware... it's temporary, it feels deceptively real and falling off can hurt. The danger comes when something inevitably causes the illusion to shatter (in my case, relapse), shocking you back into reality and bringing the rubble of your past hurling back into focus. As I said before, sometimes it's just too much to

take in. Especially when one truly believed that the sensation of happiness and wellbeing was real. It isn't. I was bullshitting myself, albeit unintentionally, but if I was really going to get well, I'd have to tear down my walls, tell all my ugly secrets, get real about the horrendous state of my life, and let these people in so they could help me. The thought terrified me. Fighting demons isn't for the faint of heart, but neither is surviving the ones that got us here in the first place; it is how we became warriors, you and I.

Which brings us to the night I wrote about in chapter three, White Porcelain. I had relapsed, I had ripped the scabs off my parents' fresh wounds, wounds I had caused, and beneath my mask of anger and bravado was raw fear. I thought I was doing so well, had everything under control – but clearly not. I concluded, better late than never, that I must really be sick, mentally ill, so royally fucked up, because I, truly, could not stop drinking. But dwelling on the "whys" did me no good, at least for the time being. I had to silence my mind and get on to "what now". I was feeling like razor thin glass that would shatter if I moved too suddenly – and so brimming with shame that I still couldn't stand at the mirror and look myself in the eye. I left my brand-new apartment and got on a bus on a January night, scared out of my mind, and went to a meeting full of people I had known now for a couple of months – whom I had told over and

over again that everything was great – and finally asked them for help. I raised my hand as soon as the meeting started.

"Hi, I'm Amie and I'm an alcoholic and a drug addict." My voice barely above a whisper.

"Hi, Amie."

"I know I've told you..."

"Can't hear you!" someone yelled from the back. I cleared my throat

"I know I told you that everything is great but I lied. Everything's not great. I relapsed. I drank and I got really drunk. It's been about forty-eight hours."

"Welcome back." A smattering of voices came from around the room.

"Everything's not great at all" the tears started flowing with my truth, "in fact, everything fucking sucks! I feel like the anti-Midas, everything I touch turns to shit. I hate my life, I hate myself, I hurt my family and my friends. I destroy anything that would allow someone to care about me because that's what I deserve. I fuck everything up. I'm really sick and I need help."

The room was silent, waiting for me to continue.

Ron, a man in his early forties and a likable, curmudgeonly smartass, started a loud, slow clap.

"Well, it's about damn time," he said, "welcome to the real world, Princess. You think it sucks now? Just hold on to your socks, Cinderella, 'cause

you just started getting sober."

The whole room burst into applause, whooping and hollering, cheering me on. I laughed, a contorted ugly-cry smile though my tears. It was probably the first external expression of how I was truly feeling.

"Good job, Kiddo. Good job," said Ron, clapping and smiling at me, "and I apologize to the group for the cross talk."

Ron was right, that was the day I started telling the truth and things began to get really hard. I was going to learn to walk without my crutches, something I hadn't done since I was fifteen years old, but I wasn't going to do it alone. I asked for help and, shockingly enough, I got it and (not) coincidentally, things began to get just a little bit better.

What changed inside of me I can't really know for sure. It may have been as infinitesimal as the movement of a single cell. One tiny organism in my body that silently shifted from one side to the other, tipping the scale. But if I had to articulate what flipped the mental switch, I'd say that I finally made a choice. I wanted to get better more, if only by one cell in my body, than I wanted to stay sick.

I call it a "Grinch Day", the day we stop blaming others, accept the reality of our situation and take responsibility for our own recovery. We can

be victims of circumstance or we can own our power, an epiphany that lets our clenched muscles relax, our hearts crack open and begin to grow. We draw a line in the sand that says, that's enough, I'm done. That's what it takes. Until I was fully committed to change, I'd been leaving the door open to back slide, as I am only able to move in one direction at a time.

The power to choose lies within us. I've come back to that many times over the years. It would become the most powerful lesson I would ever learn.

"You are not a drop in the ocean. You are the entire ocean in a drop."
~ Rumi~

CHAPTER TWENTY
Spiral, Part II

When a person releases any type of toxicity from their lives or stops accepting their drug of choice, in whatever form it takes, after years of abuse, they discover all sorts of things about themselves that may have been masked by, or mistaken for, their addiction. One of the things I unearthed was a history of severe depression which I'd attributed to alcoholism; I was wrong, they weren't one and the same. They were, however, mutually parasitic, two separate entities that fed off one another. Which came first, the depression or the alcoholism? I have no idea and, frankly, it didn't really matter to me. My substance abuse certainly exacerbated my despondency but cessation didn't cure it. I was left with chronic, sometimes debilitating bouts

of despair. Once diagnosed, I'd been put on medication and although it worked quite well initially, I hated how it began to make me feel and, personally speaking, the side effects weren't something I could imagine living with for the rest of my life.

My first twelve step sponsor – someone successfully achieving abstinence who introduces you to the program, offering guidance and emotional support in a symbiotic fashion – suggested we meet for weekly walks at the town reservoir, a three-thousand-acre forested reserve dotted with pristine watershed lakes. It was to become a transformative practice.

Once a week, we walked and talked our way around a popular three-mile paved loop where I learned, among many other things, a quote that I believe helped save my life: "Move a muscle, change a thought." (Twelve step recovery groups love few things better than a good slogan!) It introduced me to the theory that physically moving the body helps to dislodge negativity and facilitates a heathy thought process (and getting my sickly, bony ass out for some much-needed sunshine and exercise didn't hurt!). It also reintroduced me to my love of the woods, something I'd forfeited long ago to alcoholism.

The activity became so enjoyable that I began to seek out my new likeminded friends for a "walk at the Res", building healthy relationships

in a tranquil setting, eventually heading out on my own as well. I'd walk the loop after work as the days grew long, and hiked for hours on sunny weekend mornings. Woodland creatures abounded and I'd often catch glimpses of deer, even a doe with her fawn. It relaxed me and made me smile – which may not sound like much, but for me, as sick as I'd been, it was a big deal. Surrounded by the soft shapes of the forest, the whispers of the breeze rustling the leaves, the sound of water moving over rocks in the creeks, the birdsong in the trees and the rich smell and feel of earth under my feet, I found the magical world I'd claimed as a girl and then left behind. Being alone in nature, I found peace and my very first feelings of joy as an adult. I'd forgotten joy existed, let alone that it was something that might be available to me. Not to be understated, it also kept me occupied, away from dangerous environments and temptation.

As the happiness in my heart grew and my healthful body returned, I began going for short runs. It wasn't easy but I kept at it, physically challenging myself gradually, mindfully and without impunity. The endorphins, already being released on walks and hikes, increased proportionately with the pace, the distance and demand of the terrain. I was feeling strong, happy and empowered; literally and intentionally changing the chemical balance in my brain. With the blessing

and guidance of my therapist, I slowly replaced my anti-depressants with scheduled, purposeful exercise, proud to be scaling up my active participation in my recovery under the watchful eye of my doctor.

After several years, I traded regular visits with my shrink for the occasional tune-up with a sports physician. Nature was at the center of my spiritual healing and running and hiking had become my medicine. And like any medicine, if I kept taking it, it kept working and, well, conversely...

You get the idea.

"I go to nature to be soothed and healed, and to have my senses put in order."
~ John Burroughs ~

CHAPTER TWENTY-ONE
Low Self-Esteem is a Gateway Drug

My father was a builder and from him I'd learned that you cannot build a strong house on a faulty foundation. You can try, several times if you'd like, but sooner or later it's all going to come crashing down around you. That's what happened to me. In my impatience, I kept trying to build on something that was unstable. It had taken me years to get down to the point where I eventually stopped drinking but I had a lower bottom to hit. When a category five hurricane blows through, it's not over when the clouds clear. You don't just wake up the next morning to blue skies and all is well. You have to, first and foremost, make yourself safe then find life sustaining essentials – food, water, shelter. Once you've gotten your bearings, you

can begin to assess the damage, clear out the rubble and reestablish the infrastructure, while securing the resources to sustain yourself as you go through the process. After that, it would behoove you to identify vulnerabilities, to figure out what got you into that mess to begin with. Rebuilding and living happily ever after doesn't start when the wind stops blowing, it can take years. It also doesn't keep other storms from coming while you're cleaning up. Lightning strikes twice for a reason; it's attracted to something.

I was born with a near lethal case of low self-esteem. I'm not exaggerating. I nearly let it kill me. I was a very happy but nervous little kid, worrying about almost everything. Although I was a really good little girl, I'd fret constantly about getting in trouble. I am the youngest of six children and was concerned that my siblings didn't like me or want me around. After that, it was the kids at school. I started self-medicating not long after I discovered I could. I had a drink, then I had another and eventually I began to drink alcoholically, adding cocaine and pills to the mix.

I wish I could say that my journey of going from being "broken" to being "whole" was some sort of giant lightning bolt moment – a grand moment of enlightenment when everything was magically bathed in a crystalline light and it all became abundantly clear. BAM I was CURED! I would make no more mistakes and the self-sabo-

tage would end! Woo HOO! Not so much. My life has been a string of missteps and epiphanies, ranging in size and grandeur.

Every breakthrough I've ever had was preceded by some sort of really awful event that forced me to change. I mean, even if something isn't working well, it's still working, so why bother changing, right? "Change is good." "Change is bad." Whatever... change is HARD. Before I was "willing" to change, something often had to break. Usually, in one way or another, it was my heart. When a heart breaks, and I mean really breaks, wide open – that's when we are forced to choose between curling up in a ball and staying there or getting the hell up, battered and broken, and figuring out a way to glue back the pieces.

In an attempt at sobriety, as in the wake of any tempest, first I had to arrest the offending behavior. Make it through the day, minute by minute, hour by hour, without picking up a drink. Next, I had to begin to figure out how to live without needing to anesthetize myself, then without wanting to. Assessing the damage I'd done and cleaning up my mess would help with that. After a few false starts, relapsing three or four times over as many months, the switch had been flipped and I threw myself into getting sober like I'd thrown myself into getting drunk; with everything I had. I attended ten to twelve meetings a week and finally I shut up, accepted that maybe I

didn't have all the answers, and did what was suggested. It worked. I got sober.

To stay that way, I would have to discover what was missing or broken within me that caused me to turn to a life that consisted of hurting myself and those around me on a daily basis. And when I say "hurting myself and others", I mean taking a Louisville Slugger and swinging with all my might. Why in the world would someone do that, who was handed, by all accounts, a fantastic life? What made me susceptible? Why couldn't I stop? What was wrong with me? Unable to live with the damage I'd done, I had stayed thoroughly intoxicated, trapped in a vicious cycle of addiction for a very long time.

The best I can figure, my addiction was an endless circle of cause and effect. The cause was that I had something in my head that, real or imagined and in the most colloquial terms, told me I was shit. The effect was that I abused drugs and alcohol. The cause created the effect, then the effect legitimized and reinforced the cause. Something I like to call "Low Self Worth and Addiction; A Self-Fulfilling, Self-Perpetuating, Circle of Shit" and it went a little something like this:

LOW SELF WORTH AND ADDICTION: A SELF-FULFILLING, SELF-PERPETUATING, CIRCLE OF SHIT

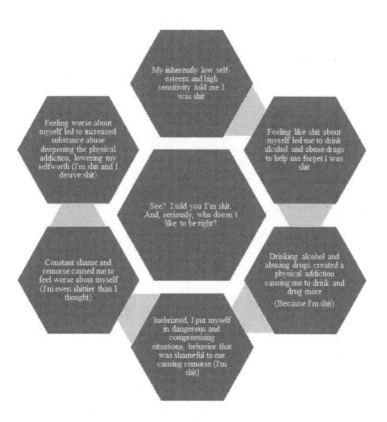

In order to move forward, it was imperative, as difficult as it was, that I became honest with myself about what I had done. I had to ask others

to forgive me and I had to find a way to forgive myself because, make no mistake, guilt can kill a person. As I was starting at less than zero, it would take years to build my self-esteem and my life, abandoning the self-sabotaging behavior that had gotten me there to begin with. Just because I stopped hurting myself with drugs and alcohol didn't mean I stopped hurting myself. It's triage, we address our issues in the order they're likely to kill us.

CHAPTER TWENTY-TWO
Ghost in the Machine, Part II

So, there I was, beating the odds and getting well, maintaining continuous sobriety, one day at a time, as they say... one year, five years, ten. My life was simple, predictable and manageable. I went to meetings, work, school, went hiking and running, spent time with friends who didn't drink and with my family – a real early to bed and early to rise kind of girl. That was it. And after all the years of chaos, it was just the way I liked it. I was a Clean Person now, cruising along on autopilot. Hey, if it ain't broke, right? As long as I keep going to meetings and doing what I was doing, I thought I was fine.

Until one day...

I met the man I would marry. I was spending

another wild Saturday night in a church basement with about seventy-five other alcoholics, business as usual in my little world. Arriving early, I sat with a girlfriend laughing about my visit with a psychic that afternoon, whom I'd asked about my romantic future. Because, honestly, what possible reason would a single woman in her thirties with the emotional maturity of a puerile twenty-something (thanks to arrested development from alcoholism) have for spending her hard-earned money on a clairvoyant other than to find out when she was going to get married? He told me I already knew my future husband, although not well, and had given me a clear physical description, which we wielded like a prince with a glass slipper. Riveted, we watched as possible suitors appeared at the top of the stairs, revealing their various ages, shapes and sizes as they descended.

"Is that him?" my friend asked.

"Nope!"

"Is that your husband?"

"No, not him!"

"How 'bout this guy?"

"Oh, lord, no!" I said. We were thoroughly amusing ourselves.

"Here comes another one!" He came into view...

My friend and I looked at each other and yelled, "THAT'S HIM!"

We had a ringer! An attributive doppelganger! I did know him, although not well, and as crazy as it sounds, the psychic was right. A year later we

were married. True story.

Relinquishing my deeply held ideologies and transforming into a well-rounded person with a positive outlook and healthy self-image was an in-depth and long-term proposition, and I hadn't gotten that far. I fell in love before I'd really begun that intensive work, happily transferring my focus outward.

We were extraordinarily happy in spite of ourselves, and given our pasts, each came to the relationship with a lot of baggage. For me, it was trust; specifically, a lack thereof. Experience had taken me from a sweet, loving, optimistic soul, albeit a nervous one, to a bitter, self-conscious, bag of doubts and taught me that, no matter how great a man appears, one can never fully let their guard down. I also believed that if I spoke my mind, if we disagreed or had an argument, he would leave. So, I swallowed my feelings and kept silent, exacerbating the fears to which I'd become a slave, causing them to come out sideways.

Eventually, he taught me that being afraid to fight meant I didn't trust him or our relationship; he found it hurtful that I thought our bond was so weak and vulnerable that an argument could break it. He was right. We worked it out rather nicely in couples' therapy and before long I settled into the safety and comfort of our relationship. I'd made a lot of progress and gained quite a

bit of personal insight, particularly when it came to my over-active imagination and the effects of my negative thought processes. I thought I'd also taken some very positive steps in healing my insecurities but, as I would discover in hindsight, only insofar as it pertained to my husband. I trusted him but I still had major trust issues. I was sober, I was no longer actively trying to harm myself, and I was happier than I'd ever been in my adult life but I can't honestly say I was well. As it would turn out, my future husband wasn't well either. But more about that later...

If something traumatic happens in your formative years, it stands to reason that, from that point on, it would stay with you and affect you. Once something happens, you can't really undo it and perception may be changed, but to what degree? Do you live and learn, gaining strength and wisdom or allow it to turn to paranoia and doubt, constantly whispering in your ear, making you jaded and suspicious? Once something becomes part of the fiber of your subconscious, do you have a choice as to how the information is stored and used?

I believe this behavior is part of our reptilian brain, the home of our survival instinct. If something proves itself to be in any way harmful, our brains store that information so we can avoid it

in the future and stay safe and, perhaps, that is why we are sometimes frightened or unsettled by what is unfamiliar or different. However, confusing a boy who broke your heart with, say, a tyrannosaurus rex might be going a bit too far – but tell that to your primal brain. Sometimes you'll hear someone (or yourself) making sweeping generalizations like "men are all alike" which, obviously, isn't true. However, if our prehistoric forebears believed that "rattlesnakes are all alike", meaning if you disturb or startle them, they will probably bite you, very likely killing you, that type of broad categorization could save their lives. I'm sure you can see both the parallel and the chasm.

To take it a step further, if a person who has never cheated on a partner, says that "all (wo)men are cheaters", ask yourself what the mathematical probability is of that statement being true? Or that "all men like meat and potatoes" or "all women like pink". They are ridiculous generalizations. If s/he has never cheated, what is the likelihood that s/he's a one off, a unicorn, or that the division of gender is absolute? Only little boys play with trucks. All little boys play with trucks. Only little girls play with dolls. All little girls play with dolls. It's gender bias and ludicrous, so if you're doing it, stop it. Stop it now. You're welcome.

Then there is the school of thought that says

our belief creates our experience. If you believe "all wo/men are cheats", or whatever nonsense you're telling yourself, the Universe will conspire to make you right. Suddenly, you're dating one lying, cheating piece of crap after another. Don't believe me? Say you dated someone who drove a green truck. Before you met this person you never particularly noticed green trucks but after you became romantically interested, green trucks abound! Now ask yourself what the probability is that this is the only area in your life in which this phenomenon occurs? It's not. It's simply what happens when something becomes part of your awareness.

How many times a day do you speak in absolutes? How frequently are you using "always", "never", or their derivatives? Are they positive or negative statements and in what way are they shaping or cementing your beliefs and the way you experience the world? How can you use this information to your benefit?

CHAPTER TWENTY-THREE
Waiting Room, Part II

We were inseparable, blissfully happy, deeply in love, and very, very silly, my husband and I. We'd been gifted a perfect little window of time. Little did we know it was the eye of the hurricane, a calm before a catastrophic storm. A trespasser was about to reenter our lives and pillage our relationship. In our case, the trespasser was cancer. Due to a previous illness, his liver wasn't doing so well and he needed a new one. That's how and where the doctors first found the cancer the year before. But it was behind us, he'd responded well to treatment and we were in the clear, all systems go. Just one more step and we'd be back on the transplant list.

I guess you know by now it was me who sat

screaming bloody murder in a waiting room at Hartford Hospital when the doctor returned from surgery and told me my husband's cancer was back and extremely aggressive.

We'd married the first week of October, two thousand and one, just about three weeks after the September eleventh attacks. We'd asked that anyone planning on taking an airplane to be at our wedding to please not come. With things so unstable, their safety was paramount. We were planning to go to St Lucia for our honeymoon and we cancelled that as well, choosing instead to take a beach cottage on Cape Cod, a three-hour drive from our home.

It happened just before our six-month wedding anniversary.

We finally got on a plane again. Headed for West Palm and South Beach, Florida for a belated honeymoon at the half-year mark and had a truly wonderful time. That trip was a gift, and the last time we would ever be happy and trouble free. Everything changed upon our return home. In times of extreme trauma, the mind can be very kind. Although some if it I recall with photographic-like clarity, as I sit and write this nearly twenty years later, I still have only intermittent memory of much of what took place in the time following. The details of the day we got the news, which is something I do remember, are in the first

chapter of this book. The surgery and the devastating revelation came on the day of our six-month wedding anniversary.

When I left the hospital later that afternoon, I walked outside toward the parking garage with my eldest niece -- my sister's daughter who happened to be visiting from California when this all occurred -- and my brother-in-law, my husband's younger brother. I can't recall if my father-in-law, who had been with us during and after the surgery, was walking with us, but I don't think he was.

There's something especially contradictory and repugnant about walking outside into the sunshine after a trauma, having it track you out into the real world. Once outdoors, I recall breaking down again, feeling faint and overwhelmed, needing to quickly sit down on a nearby curb. A doctor, who was also exiting the hospital, saw me and asked what was wrong. When told we'd just received some devastating news and observing my emotional state, he asked if there was anything I needed. I shook my head no and thanked him.

He said, "Are you sure? Perhaps I can get you a sedative?" Ah, and there it is, the understatement of the century. The three of us, knowing my history with drugs and alcohol, looked at each other.

"Maybe," I said, "Do you have a truck?" at which my niece, brother-in-law and I burst out laughing.

The doctor shook his head and said, "I'm sorry, I

don't understand..."

I looked up at him, laughing and crying, and said, "A sedative? Doc, you ain't got enough sedatives in this building for what I need right now."

We nearly peed our pants.

Our emotions run amok, the doctor walked away thinking, I'm sure, that we were all nuts. It would not be the last time improper laughter would get the best of us but, being the only kind of laughter we'd have access to for a good long time, we would take it.

CHAPTER TWENTY-FOUR
Lizard's Tail

Time would not heal this wound. There would be no eventual evanescence of emotion. So, without any recourse, I sought refuge through physical distance and abscission of the faulty organ that lie beneath my ribs. I took my shriveled, broken heart from my chest, with its evocative, seeping contents, and wrapped it in a downy layer of cotton. I needed to sheathe it in padding, to muffle the feelings and dull them down, then pack it away in a soundproof, watertight box, safe away from the light, to keep it from coming out and torturing me. It was the only way I could have survived it. And then, having successfully removed my heart - like a lizard's tail - I got down to the business of growing a new one in its place.

CHAPTER TWENTY-FIVE
Birds of a Feather, Grief, and Broke, Part II

In the aftermath of my husband's death, and still dealing with the damage I'd done to myself as an alcoholic and the predispositions and low self-worth that allowed me to become one, I went into the second downward spiral of my life, albeit this time sober. I believe at this point I was completely broken. I didn't drink but, thrust from the insulated capsule of my marriage, I made terrible life and relationship choices and was forced to apply for government assistance. Yep, the shitty boyfriends and the food stamps, that was all me.

After my husband passed, I moved back to my hometown in California to be near my family and

make an attempt at rebuilding my life. Overcoming alcoholism and drug addiction is a ferocious beast, but this... this was worse. Watching my husband fight, then lose, his battle with cancer, and the time that followed, was the most brutally excruciating experience of my life. In the beginning, it was all I could do to hold myself together just long enough to buy some groceries, get to a meeting or have lunch with my sister. I'd longed for the gentle, nurturing company of my family and closest friends but could only take it in very small doses. For my family, I faked it; pretended I was happy, smiled as I waved goodbye then hurried inside just as the daily gut punch of grief would land, folding me in two. The rest of my time I spent, literally, in the fetal position.

It took me a year to feel strong enough to begin formal grief therapy. The earthbound angels at Hospice provide complementary counseling and for the next two years I took advantage of their one-on-one counseling program, going twice a week, then once a week, then bi-weekly.

Four years after losing my husband, I began the first of three really bad relationships in a row, eventually taking full responsibility for what was happening. I stripped my life down to the bare bones and, at long last, set myself on an intensive path of self-discovery.

During my self-imposed year-long sabbatical, I

journeyed inward to identify and heal my intrinsic, self-held beliefs. As I dug down to the core of my issues, which I found nestled, nice and cozy, in the same place that told me I was shit, I found other the ugly spawn of my low self-esteem – my feelings about money. More specifically, the fear of never having enough of it, which I never did.

Why was I always so broke? I'd had worked my ass off! I had chosen a career in holistic wellness, gone to one of the best schools in the country, became highly trained in my field and ten years prior, in nineteen ninety-eight, opened my first business. Within a year, the business became so successful that that I barely had time to conduct interviews to hire help. I was booked up months in advance and was working nearly double the hours I had intended to work, almost having a meltdown from sheer exhaustion after nine months in business. *In the holistic wellness field.* Ah, yes, the irony of it all.

I wasn't really a spender and didn't waste money on frivolous things. I'd fallen far behind on all my bills and was constantly worried about unintentionally bouncing checks. Money was so tight I would often be overdrawn by only pennies and was constantly getting hit with overdraft charges, which would cause more checks to bounce, causing more overdraft charges, ad nauseum. How could this be?

For starters, I was vastly undercharging my clients. Because I didn't recognize my own worth, I placed a low value on what I did. I was constantly giving deep discounts and incentives and making about half of what other people in the industry were earning because I was fearful of asking for what I was worth. The discounted rates were representative of the low value I placed on myself.

Over the years, the creative vision of my business evolved. I was oddly fearless in taking innovative professional leaps, fulfilling every new dream and concept. I was a perfectionist in my work, proud of my professional reputation, and continued to be successful in terms of marketing and attracting business. Of course, I charged more and more as the cost of living increased – but so did my expenses, and I continued to be in financial straits. Just as I would get ahead, something would happen and I'd fall behind. There was never going to be enough. Why? Because I was never enough. It was a vicious cycle and it had to stop. It was going to stop. I had to face my fears, challenge those negative voices, prove them wrong, and shut them down, once and for all. And that's exactly what I did. Not for one year. Not for two years. For five. Five glorious years of self-discovery and following my bliss. For me, that's what it took.

PART III
Kintsukuroi Heart

*"When we stop seeing ourselves as broken
We can lift up our eyes and see the world."
~Amie Gabriel~*

CHAPTER TWENTY-SIX
Baptism by Fire, Part II

After being stuck in grief for ten years and, not coincidentally, after getting to the core of my issues, I had a ceremony on the river bank with one of my dearest friends and jumped into the water, setting myself free.

Nothing really "happened" on that riverbank. No magic spell or incantation could have brought me back to the world of the living or made me suddenly feel good about myself. The transformation hadn't happened, it couldn't happen, until I was ready. What my friend and I found at the river that day, hidden among the trees, water and singing birds, was the woman I thought I had lost, yet she was right there all along... just waiting until I was strong enough to come back out again.

Time and work had been the catalysts, the ceremony was the beautiful packaging, and my friend had been the gentle, loving, delivery system. They had all conspired to become the mechanism in presenting the one gift we all truly need to move on and to be happy again. The gift itself hadn't come from any outside source, it had come from within. What was given that day was simply permission. Permission to move on, live my life, and to be happy again.

But giving a gift is only half of the equation. To receive the gift, to actually unwrap it, acknowledge it, accept it and agree to allow it into our lives, that's all on each of us. It had to come from inside and I had to be entirely ready to embrace it. And I finally was. I gained awareness of what I'd been doing and had given myself permission to get over it and move on. That day, I remembered some very wise words spoken by my grief therapist when she was releasing me from therapy. They finally resonated deep inside and rang true: I wasn't going to be alright… I already was.

CHAPTER TWENTY-SEVEN
Eighteen Dollars, Part II

My best friend, Dorian, and I are the ones who began actively practicing the Law of Attraction, scraping our pennies together to take a zip lining trip, deciding to spend a whopping eighteen dollars on trip insurance.

What follows is the immediate and long-term return on that eighteen-dollar investment:

- A penalty-free zip lining "Do Over" when Dorian got sick just before the trip.
- An impromptu party with the other zip liners while we waited out the storm.
- An invitation to join some of the guides that afternoon while they practiced a sport that had been gaining popularity in the US and was about to be introduced at the resort, although we'd

never heard of it before. It was called Stand Up Paddling. We had a blast and saw two Bald Eagles while on the river.

- A private zip line canopy tour the next morning.
- Because we had paid for a three-hour tour (*a three-hour tour...*) and we'd already completed their training program the day before, we spent the entire time zipping. It was enough time to go through the entire tour twice!

Here's what happened in the following years, because we invested and believed. (Not all, just the highlights):

- July, two thousand and twelve, a whitewater rafting trip at the same resort, this time staying in rooms at a charming B&B.
- September, two thousand and twelve, a weekend trip to a grand mountain resort in New Hampshire where we would return many times in the years to come (and, yeah, we still have to have our own rooms).
- Individual trips to see our families; Dorian going to the Caribbean islands once a year, and me traveling back to Santa Barbara every six months.
- March, two thousand and fifteen I went to England and Paris
- September, two thousand and fifteen, twenty years after we met, Dorian and I spent ten days in Ireland to celebrate our friendship.
- April, two thousand and seventeen. I went

to Osaka, Kyoto and Tokyo, Japan
- October, two thousand and sixteen, we went to Vegas, Baby!
- October, two thousand and eighteen: Sitting on a blanket enjoying a picnic in the Parc Champ de Mars at sunset, gazing up at the Eiffel Tower in Paris, France, where I now live. Dorian and I lifted our glasses of sparkling cider to toast, just as we have done on every single trip we've taken since that day in the spring of two thousand and eleven.

"Here's to eighteen dollars."

"Eighteen dollars. I'll drink to that!"

CHAPTER TWENTY-EIGHT
Daydream Voyages, Part II

Sixth entry, April 20, 2015
"FROM DREAM TO REALITY

So, twenty-nine hours after I'd awoken in my beloved Tempurpedic back home, I arrived in Chipping Campden, England, a gorgeous, bustling village about forty miles northeast of Oxford. The second I arrived, I knew it was going to be everything I'd hoped for. It had rows of stone cottages, mossy tiled roofs, cobblestone streets, and trails of wood smoke curling out of chimneys lightly scenting the crisp afternoon air. If not for the modern-day cars and clothing of passersby, I'd have sworn I'd been dropped back in time. I paused on the sidewalk and tried to soak it all in... not an easy task amid exhaustion that tee-

tered on the brink of delirium! Was I really here? Was I really in ENGLAND? It was all so surreal!

The majority of clouds had lifted and the overcast day had turned mostly sunny, but in the long shadows of late afternoon it felt uncomfortably cold to this sleepy California girl and made me anxious to get indoors. I was even more anxious to get my blasted backpack which, at this point, felt like it was loaded with rocks, off of my aching shoulders and dump it in a heap! I made my way into the pub at the Volunteer Inn, my home for the next two nights, and the first thing I noticed was how blissfully warm it was inside (much to my delight, this was about to become a recurring theme in this particular village!). Several gentlemen sitting at the bar having a pint acknowledged my presence with a quick nod, and a woman sitting by herself at a corner table gave me a warm, reassuring and much needed smile. I was soon greeted by the bartender as she appeared from a back room, dropping steaming plates of food to the men at the bar and refilling their drinks. She was young, energetic, and a multitasker indeed! In addition to tending bar and waiting tables, she checked me in, gave me a tour of the inn and showed me to my room on the first floor. It was quite large and had sliding glass doors that led to my private patio, with views of the back garden, creek and rolling fields beyond. It wasn't particularly fancy but would do quite nicely, thank you very much! She

apologized for the chill in the air, explaining that they had upgraded my room at the last minute. They had a group coming in and decided to put them all together upstairs, and felt this room would be quieter for me (YAY!). She proceeded to crank up the radiators saying, 'Now let's ge'cha some heat!' Ahh, music to my ears! Asking if there was anything else I needed, let's see: bed, shower, internet, coffee maker, and heat on the rise, nope! I'm good! she closed the door behind her and left me to the heavenly peace, quiet and solitude of my room, which fully enveloped me and draped over me like a quilt, muffling all sound. I hadn't realized it until that very moment but, other than various restroom stalls, it was the first time I'd been alone in what seemed like an eternity. It was silent, such a profound and unexpected relief to my ears. I stood there alone in the middle of my room and stared into the semi-darkness. The curtains were closed and tiny particles of dust gently swirled and danced in the slices of sunlight that cut between the panels of the drapes. The difference between the constant, frenetic energy of my journey and stepping into the sanctuary of that room was distinct, audible, and palpable. Like Dorothy's house getting dropped out of the twister into Oz, it was as if I'd landed with a thud and everything went quiet... and I stood there and let it surround me. I could stop now. I was finally there. I was in England. I was in the Cotswolds. This fifty-something, first-time traveler who set

out alone on a crazy, incredible, lifelong dream of a journey had actually arrived. Car, bus, plane, train (train, train, train, train... yeah, I think it was five trains, but whatever), bus, car. Approximately five thousand seven hundred and fifty miles.... and about forty years. It was no longer a dream and had now become my life, the once homeless drunk girl. I just stood there for a minute and really took that in. I know what you're thinking... you're thinking I cried again, right? Wrong. I cracked a smile, started laughing, ripped that bloody backpack off of me and (chalk it up to sleep deprivation) jumped up and down like a lunatic saying "Oh my God! I did it, I did it, I did it!" Woo HOO!

As much as I wanted to get out of my scuzzy airplane clothes, take a ridiculously hot shower and drop directly into bed, the village beckoned, as did my desire to reset my body clock as quickly as possible. So I decided to unpack a bit and go for a quick walk down the main street.

The rest of my night consisted of a delicious dinner at Maharaja, the Inn's East Indian restaurant, finally taking that MUCH needed shower, checking in on Facebook for a touchstone with "reality" and home, and then a good, long sleep...

When I woke the next morning, I opened my eyes, looked around the room and, ever the lady, said out loud, "Holy shit! I'm in England!"

My first morning came rife with possibility! A new country to delve into, a new town to explore, people to meet and, of course, my first real Full English Breakfast, about which I have four things to say: 1) It does not disappoint. 2) It is not for the faint of heart. 3) It is not for vegetarians. 4) It probably shouldn't be eaten every day (I'm no doctor, I'm just sayin'). Two eggs, two pieces of toast, two slices of bacon – *mmmm bacon* – two large sausage links, a fried tomato, fried mushrooms, baked beans, juice, coffee and/or tea (I had both), breads, butter, jam, yogurt, fruit... OMG. Now THAT, my friends, is BREAKFAST!

After breakfast (and although I was so dang full I couldn't take a full breath) I ventured (read: waddled/lumbered) off to explore the town. My first destination was up the hill to St. James Church. I found it utterly mesmerizing. The soaring spires, the curve of the arches, the physical and psychological immensity of the huge wooden doors, the cemetery, the vivid imagery of the bursting bright spring green and yellow daffodils juxtaposed against the ancient stone and feathery, pale lichen of the gravestones, the sweeping views of the countryside beyond. A church has stood on this site since 1180 AD and the West Tower of the church was constructed in about 1500 AD. I felt it a privilege to be meandering these grounds and found it very moving. I spent the better part of an hour there all alone and found myself, once again,

just trying to take it all in. Imagining the centuries of people who had walked these paths before me. Those laid to rest here... what their lives may have been like. I thought about those who will walk where my feet have just been, many years after I'm gone. I felt I was physically experiencing history. Moments like this were why I came to England. The experience left me awestruck and humbled.

I walked back down the hill into the town and began to explore the delightful little shops, their windows irresistibly teasing all sorts of goodies that lie within. Delicate tea sets and hefty mugs, whimsical items for the home, gorgeous wool coats, scarves and sweaters, woven tea towels and linens, beautifully handmade crafts, scrumptious scones, tea cakes and breads... their fresh baked aroma filling the air and luring you in! I was graciously greeted as I entered each shop, but what I was taken by the most, even beyond the warmth of the welcome, was how deliciously cozy warm in temperature they all were! The heat was turned up, woodstoves were stoked, and so many of the shops had real wood burning fireplaces, flames dancing and welcoming all visitors inside! I'd never experienced anything like it in regular places of business. It was so inviting and made the chilly outside temperatures so much more tolerable! I shopped in leisurely comfort, sipped English tea at a tiny table next to a woodstove,

and I happily entered a restaurant, shed my coat and scarf and enjoyed a meal in front of a fire. I was practically purring like a cat! All in all, it was my observation that the fine people of Chipping Campden, England are NOT afraid to light a fire or crank up the heat and, from a woman who has gone through life on a spectrum of (pre-menopausal) personal comfort that ranges from chilly to freezing, ninety percent of the time, for as far back as I can remember, I say a resounding and heartfelt thank you! I blissfully wandered the town into the late afternoon.

My second day. And every day after, was spent much like my first. I was lost in my own little word of roaming the village, browsing shops, sightseeing, taking pictures, and, as I would be biking from village to village over the next week, being outfitted and getting ready for the bike ride.

After that, it was on to Paris where I would join my handsome gentleman tour guide – a Frenchman to whom I was introduced by one of my dearest friends back in California. He and I briefly met in Los Angeles the month before, and oh, what a tour it's been! We fell in love (blame it on Burbank, not Paris!) and he's been sharing my life and showing me the world ever since!

The first two years he and I were together, we made our home in Los Angeles, California. The three years after that, in Paris, France. Who knows

where we'll go next? But we do know that, wherever it is, it will be together.

It should be pointed out, incidentally, that I met him while chasing my own dreams...

CHAPTER TWENTY-NINE
Kintsukuroi Heart (More Beautiful)

As you now know. All the chapters in part one of this book are my personal life experiences.

Having said that, this book isn't really about me and my struggles, failures, and successes. It's about *you and me*. It's about all of us and the challenges we face in our lifetime. That's why I wrote part one of this book, at times, in third person narrative and often ambiguously, to remove myself and the details of the circumstance, hopefully making it more widely relatable, so you could insert yourself and your situation into it.

Roy T. Bennett said, *"It doesn't matter how many times you get knocked down. All that matters is you get up one more time than you were knocked down."*

Whether it's alcoholism, an abusive relationship, recovering from loss by death or physical separation, negative beliefs, unemployment, low self-worth, allowing yourself to be stuck in a crappy job or otherwise remain truly unhappy, it doesn't matter. It all requires action and a recovery process. No one escapes the human condition. We all have ghosts and many of us have had to, or will have to, do something that terrifies us in order to step away from one thing and toward something else, whether by choice or circumstance, to honor ourselves.

Because moving forward in our lives is a process, each stumbling block you encounter can, if you choose, become a stepping-stone. Every time I did something incredibly stupid or destructive, I could view it as proof that I'm crap and don't deserve better – an excuse to continue the self-destructive behavior – or see it as an opportunity to use as a lesson. I can trip over it and fall down again or step up on top of it and use it to build a staircase to a better self.

And so, Dear Reader, we all have heartbreak, don't we? But just because we've had our hearts broken doesn't mean we, ourselves, are broken. I invite you, when you're able, to examine your broken heart, crawl inside of it, assess the damage, be alone and quiet with whatever internal knowledge you're running from and keep hidden deep inside. It isn't trying to hurt you, it is trying to

teach you. I believe that what you will find inside your wounded heart, beneath the shards and rubble and wrought from your pain, is molten silver, platinum, bronze and gold in the form of compassion, empathy, understanding, and most of all, love. You may not recognize it now but it's there, for love is energy and energy doesn't die, it only changes form.

When it comes to love, we can identify it because we have known it. We cherish it, because we have lost it. When we meet others who have also known a profound and cutting loss, we know we've found someone who innately understands us, as we understand them. A broken heart, once the cracks are filled in and sealed, is bigger.

Loss and heartbreak change a person by adding depth and layers. When you're ready to begin the work of repair, take those precious things, that understanding and love, and give them first to yourself. Pour them back into your broken, withered heart. Instead of running out of the gaping holes and fissures and spilling out onto the ground, it can cauterize them. It can seal and close them. Fill them up. Because your love is precious. It is molten gold, it is liquid silver and platinum and it will mend and heal your Kintsukuroi Heart, which, like you, we now know is far more beautiful for having been broken.

~NAMASTE~

ACKNOWLEDGEMENT

It is with profound gratitude that I would like to thank the following:

Mother nature for being my teacher, gym, therapist and church. The friends of Bill W. without whom I simply wouldn't be here. Andrea, Colleen, Diane, Dorian, Eleanor, Jane, Kathy, Michele, Mikah, Sara, and Susan who read the first draft of this manuscript, offering me constructive criticism, praise and encouragement. My editor, Sandra Mangan. All my friends and family who knew me before and during and have stuck with me for all these years. The journey continues! To the OS; A, M, N, E, J, V. To Lori H and Leslie D who have shown far more forgiveness than I thought humanly possible. You are my spirit animals! The rest of my tribe, you know who you are. All the subscribers and viewers on YouTube and the readers of this book and my blog who allow me to do the most important work of all; to give back. What a privilege it is!

And most of all, to DSM, my BFF, JRG and RAC, my angels, and JLF, my heart.

ABOUT THE AUTHOR

Amie Gabriel

Holistic wellness expert and owner of Daydream Voyages Yoga, Meditation & Mindfulness, Amie is a certified yoga, meditation and group fitness Instructor specializing in mind-body fitness. She was a spa owner and licensed massage therapist for nearly 20 years, focusing her practice on providing women with sanctuary from our busy lives and teaching the importance of self-care and inner healing. Amie created a system of multi-sensory, guided meditations and nature-based yoga classes which she has presented at world class destination spas across the country. Expanding on the concept of "Mind, Body & Spirit", Amie has felt deeply compelled to share her passion for the art of relaxation & mindfulness, whole body fitness and wellness, and the necessity of creating a space in our busy lives for "Peace, Quiet & Solitude" and believes it to be her true calling. She lives with

her boyfriend in Paris, France.

Made in the USA
Columbia, SC
07 January 2021